THE ROYAL TOUR
A SOUVENIR ALBUM

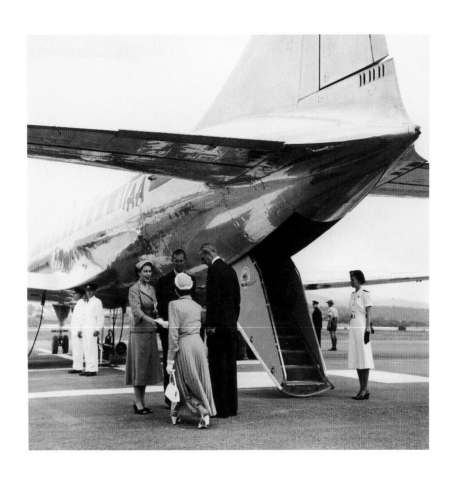

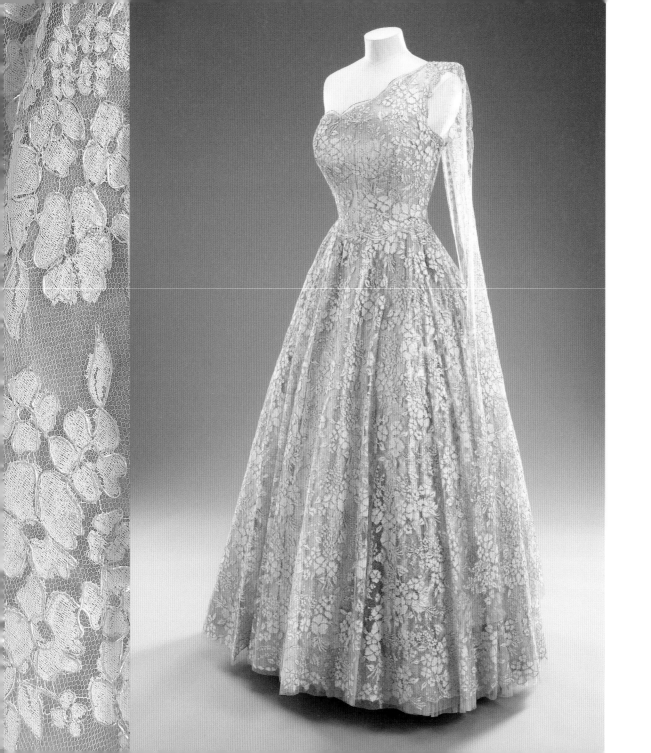

THE ROYAL TOUR
A SOUVENIR ALBUM

ROYAL COLLECTION PUBLICATIONS

Published by Royal Collection Enterprises Ltd
St James's Palace, London SW1A 1JR

For a complete catalogue of current publications, please write to the address above,
or visit our website on www.royalcollection.org.uk

© 2009 Royal Collection Enterprises Ltd
Text by Caroline de Guitaut and reproductions of all items in the Royal Collection
© 2009 HM Queen Elizabeth II

012970

ISBN 978-1-905686-24-7

British Library Cataloguing in Publication Data:
A catalogue record for this book is available from the British Library.

Compiled by Caroline de Guitaut
Designed by Peter Drew of Phrogg Design
Typeset in Garamond
Production by Debbie Wayment
Printed and bound by Studio Fasoli, Verona

Colours and proportion of the flags shown
on the endpapers have been stylised.

Printed on Symbol Tatami White
Fedrigoni Cartiere SPA, Verona

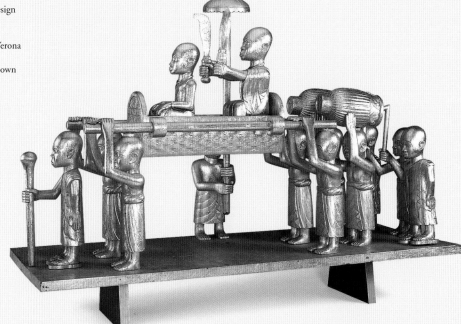

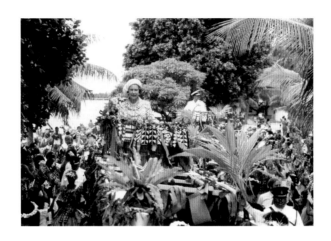

2009 MARKS THE SIXTIETH ANNIVERSARY of the formation
of the modern Commonwealth and The Queen's fifty-eighth year
as the Head of the Commonwealth. In her Commonwealth Day
Message, delivered on 9 March 2009, The Queen spoke of the
development of the Commonwealth over the last six decades:

*We can rightly celebrate the fact that the founding members' vision
of the future has become a reality. The Commonwealth has evolved
out of all recognition from its beginning.*

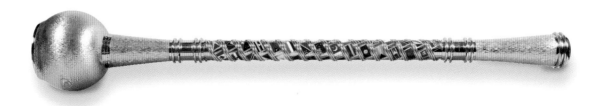

Extract from the London Declaration, 26 April 1949:

The Government of India have informed the other Governments of the Commonwealth of the intention of the Indian people that under the new constitution which is about to be adopted India shall become a sovereign independent republic. The Government of India have however declared and affirmed India's desire to continue her full membership of the Commonwealth of Nations and her acceptance of The King as the symbol of the free association of its independent member nations and as such the Head of the Commonwealth.

The Governments of the other countries of the Commonwealth, the basis of whose membership of the Commonwealth is not hereby changed, accept and recognise India's continuing membership in accordance with the terms of this declaration. Accordingly the United Kingdom, Canada, Australia, New Zealand, South Africa, India, Pakistan and Ceylon hereby declare that they remain united as free and equal members of the Commonwealth of Nations, freely co-operating in the pursuit of peace, liberty and progress.

When Queen Elizabeth II came to the throne in 1952, she assumed the role of Head of the Commonwealth from her father, King George VI. Her Majesty has always placed considerable emphasis on this role and while undertaking her first Commonwealth Tour between 1953 and 1954, she spoke of the sense of the newly created Commonwealth when she gave her Broadcast to its people from Government House, Auckland, on Christmas Day 1953:

The Commonwealth bears no resemblance to the empires of the past. It is an entirely new conception built on the highest qualities of the spirit of man: friendship, loyalty, and the desire for freedom and peace. To that new conception of an equal partnership of nations and races I shall give myself heart and soul every day of my life.

The modern Commonwealth owes its origins to the London Declaration, delivered by King George VI at St James's Palace on 27 April 1949. After the Second World War the shape of the British Empire began to change drastically, with India gaining independence in 1947, the simultaneous creation of the new state of Pakistan, and a wave of decolonisation. Having attained independence, India declared a wish to adopt a republican constitution, but also wanted to remain within the Commonwealth. Following a series of meetings in London between 21 and 27 April, the Commonwealth Prime Ministers accepted this proposal and agreed in the London Declaration that the monarch would be a symbol of the free association of independent countries and the Head of the Commonwealth. The Declaration (opposite) meant that republics could be members, as they could accept the monarch as Head of the Commonwealth while retaining their own Head of State.

In 1952, at the age of 26, The Queen was Head of a Commonwealth consisting of just 8 members. Today the Commonwealth has 53 member countries, including the 16 of which The Queen is Head of State. Each of these also recognises The Queen as Head of the Commonwealth.

In December 1960 it was announced that The Queen, at her own instigation, had adopted a personal flag to be flown on any building, ship, car or aircraft in which she was staying or travelling in a Commonwealth country. Designed at the College of Arms, the flag consists of an initial *E* ensigned with the royal crown and surrounded by a chaplet of roses. A number of Commonwealth countries – Canada, New Zealand, Australia, Jamaica and Barbados – adopted their own versions of the flag, to be flown as a personal flag when The Queen is in their country. Each of these flags incorporates the country's arms with the same design.

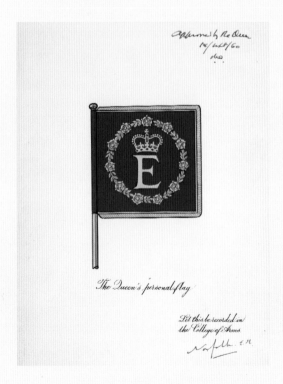

The Queen's personal flag

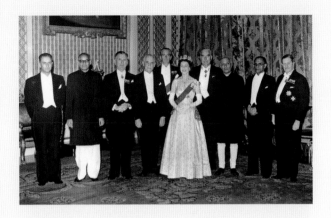

The Commonwealth Games are held every four years. Her Majesty attends regularly, including either the opening or closing ceremony, and since 1958 has started the baton relay.

As Head of the Commonwealth, The Queen regularly meets Commonwealth leaders in London, in national capitals and during the biennial Heads of Government Meetings. At each of the Heads of Government Meetings, Her Majesty visits the host country, meeting the leaders in individual audiences and at larger formal receptions. The Queen also receives Heads of State of Commonwealth countries on state visits to the United Kingdom.

On Commonwealth Day (the second Monday in March) The Queen makes an annual broadcast to the Commonwealth, attends the multi-faith observance at Westminster Abbey, and the Secretary-General's reception at Marlborough House – the headquarters of the Commonwealth Secretariat since 1965.

On ceremonial occasions the Commonwealth Mace and a set of 56 toasting goblets are used. The Mace (illustrated on page 5), which is made of 18-carat gold and adorned with the flags of the Commonwealth countries, and the silver-gilt goblets, each decorated with a member country's flag, were a present to The Queen, as Head of the Commonwealth, in 1992, on the occasion of the fortieth anniversary of her accession to the throne. At the time of the presentation, the Secretary-General, Chief Emeka Anyaoku of Nigeria noted that:

The Commonwealth has a special affection for The Queen who, over the past four decades, has been able to fashion a unique relationship with its leaders and people.

Queen Elizabeth II has developed this unique relationship with the people of the Commonwealth by making regular tours and visits throughout her reign. She has visited every country in the Commonwealth with the exception of Cameroon, and has made many repeat visits. A third of all her travels abroad have been to Commonwealth countries, totalling more than 150 Commonwealth visits. In so doing The Queen has undertaken some extraordinary journeys and travelled further than any other monarch in history, circling the globe several times.

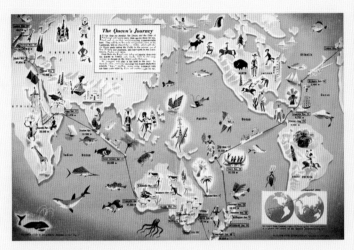

In addition to the first Commonwealth tour of 1953–4, The Queen and The Duke of Edinburgh undertook major tours to India and Pakistan (1961), Africa (1961) and the Caribbean (1966). The Queen's five-week tour to Australia in 1970 featured in her Christmas broadcast that year and during the tour she wore this orange chiffon evening dress by Norman Hartnell for a dinner at Government House, Sydney.

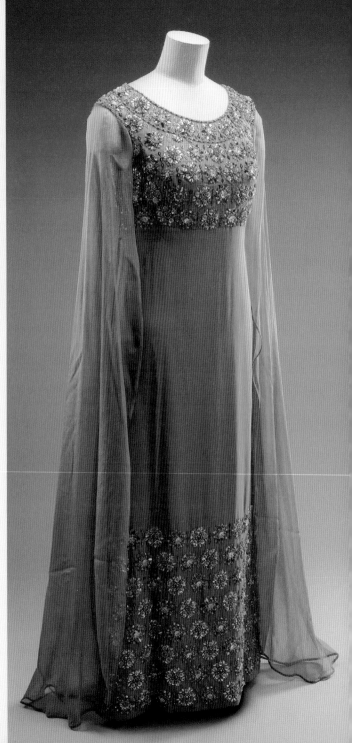

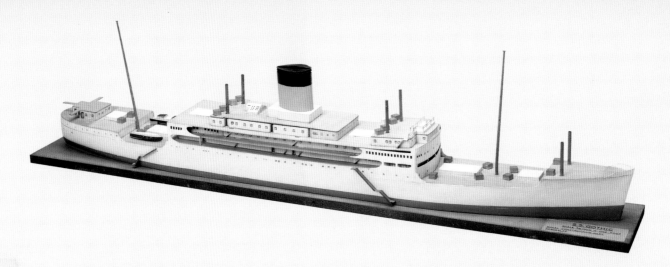

The Queen's first and longest Commonwealth tour, which lasted seven months – from November 1953 to May 1954 – followed her Coronation in June 1953. The tour encompassed the West Indies, Australasia, Asia and Africa and covered over 40,000 miles. The Queen and Prince Philip flew to the Caribbean and thereafter the tour was undertaken on board the liner SS *Gothic*. The itinerary for the tour was drafted in October 1952 and the initial press announcement was made on 26 January 1953. Months of meticulous planning were needed to coordinate the logistics for the tour, from the detailed itineraries for each country visited and the daily programme of events, to the accommodation of the royal party in hundreds of different locations along the length of the tour route, and the shipment of baggage between cities. An estimated eight tons of baggage was embarked aboard the *Gothic*, and the official party accommodated on board consisted of two ladies-in-waiting, three private secretaries, a press secretary, an acting master of the household, two equerries, twenty officials and staff, seventy-two naval staff, nine members of the press and a band of the Royal Marines.

The Queen and The Duke of Edinburgh undertook the final homeward journey, from Malta to London, on board HMY *Britannia*, which had been commissioned in January 1954. From that date *Britannia* was used on many subsequent tours to Commonwealth countries, enabling visits to distant and

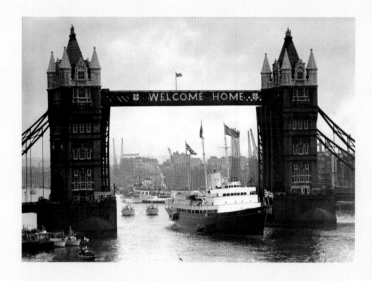

otherwise inaccessible islands, and providing a royal residence at sea, where official receptions and dinners could be held.

The Duke of Edinburgh continues to be closely involved with the Commonwealth, having accompanied The Queen on all her tours and visits over the last fifty-seven years. Tour itineraries often incorporate separate engagements for The Duke of Edinburgh, thereby allowing The Queen and The Duke to meet a greater number of people and organisations. The Duke has also undertaken some independent tours of the Commonwealth. In 1956–7 he travelled 40,000 miles on *Britannia* visiting Kenya, the Seychelles, Ceylon, Malaya, New Zealand and New Guinea, as well as the Antarctic. On his return, The Duke gave an illustrated talk about his journey to schoolchildren at the Festival Hall. He was also given a Welcome Home luncheon by the Lord Mayor at the Mansion House. In his speech on this occasion Prince Philip spoke of his commitment to the Commonwealth:

I believe that there are some things for which it is worthwhile making some personal sacrifice, and I believe the British Commonwealth is one of those things, and I, for one, am prepared to sacrifice a good deal if by so doing, I can advance its well-being by even a small degree.

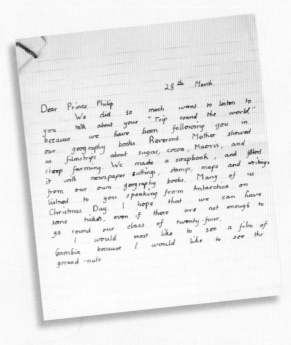

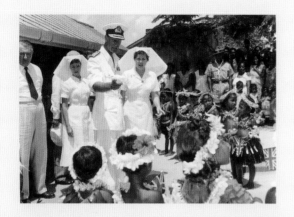

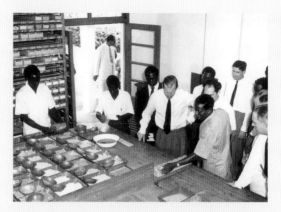

The Duke of Edinburgh has been closely identified with a number of Commonwealth organisations, including the Commonwealth Games Federation (President 1955–1990) and the Royal Commonwealth Ex-Services League (Grand President from 1974). The Duke of Edinburgh's Award Scheme, which was initiated by His Royal Highness in 1956, has had nearly six million participants worldwide, of which over four million have come from Commonwealth countries.
In 1956 The Duke also founded the Commonwealth Study Conferences. The first conference was held in Oxford and was attended by 300 men and women drawn from every country of the Commonwealth, meeting to discuss the human problems of industrial communities. The idea for the conference came as a result of Prince Philip's visit to Canada in 1954, when he saw some of the new and developing industries in the far north of the country. The conferences have continued to be held every six years.

In 1957 The Duke founded (and still presides over) the Royal Agricultural Society of the Commonwealth, the only non-governmental organisation representing agriculture across the Commonwealth.

The Queen generally undertakes tours and visits outside the United Kingdom on the advice of her ministers. Once a tour has been suggested and agreed, an official invitation is sent by the Head of State to The Queen, who sends a personal reply in return. The Queen and The Duke of Edinburgh are then consulted about the suggested route and itinerary and are closely involved in the planning process. Once the programme has been outlined, a reconnaissance visit is undertaken before the programme and other details are finalised.

To mark the important principle of friendship that underlies The Queen's visits to Commonwealth countries, or her attendance at Commonwealth Heads of Government Meetings, an exchange of gifts is usually made. Gifts to Heads of State, or to Governors-General, often include the presentation of honours.

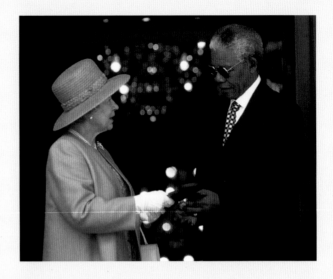

The Queen has awarded the Order of Merit (Honorary) on three occasions to those who have rendered exceptionally meritorious service from Commonwealth countries, including President Sarvepalli Radhakrishnan of India in 1963, Mother Teresa of Calcutta in 1983 and Nelson Mandela in 1995.

In The Queen's Realms, gifts sometimes take the form of scholarships, bursaries or foundations. The first instance of such a gift came during the 1959 tour of Canada, when

the Government of Canada instituted a £1million fund for research into children's diseases. Photographs, books and films recording aspects of The Queen's tours have also regularly been given, as have flowers and food, including Kamloops trout from British Columbia in 1957 and five tons of dried fruit from the Australian Dried Fruits Association, at Mildura on 25 March 1954. The latter was distributed to children's homes in the United Kingdom. Some of the more unusual gifts have included a two-year-old filly, presented by the Government and People of Australia during the Silver Jubilee tour, and a horse, the famous *Burmese*, given to The Queen by the Royal Canadian Mounted Police during her 1973 visit to Canada. Wild animals have also been presented, all of which have been placed in the care of London Zoo.

The majority of the gifts which The Queen and The Duke of Edinburgh receive on tour are examples of traditional craftsmanship and local produce, often presented in traditional ceremonies specific to indigenous peoples of a region or country. The extraordinary variety of these gifts illuminates the rich diversity of cultures represented by the two billion inhabitants of the Commonwealth.

At the Commonwealth Heads of Government meeting in Uganda in November 2007, the President of Botswana presented The Queen with a gold and diamond brooch in the form of an ear of sorghum. Sorghum, a type of millet, is the main local crop in Botswana.

A further significant aspect of preparations for The Queen's tours involves the planning of her wardrobe. For her first Commonwealth tour, The Queen took over one hundred dresses, including her Coronation Dress, designed by Norman Hartnell, which she wore on three occasions during the tour (in Wellington, Canberra and Colombo).

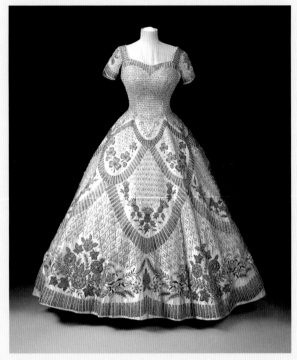

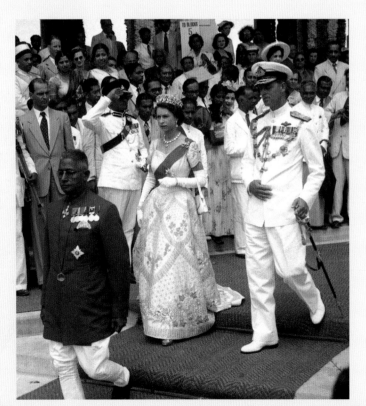

The dress was flown out to join the tour in Wellington on 2 January 1954. People in every city she visited, particularly in Australia and New Zealand, became increasingly fascinated with her dresses, hats and beautiful evening gowns, and the magnificent jewellery which the young Queen wore.

Hartnell, then The Queen's couturier, designed a large number of dresses for the tour, notably the evening gowns, many of which incorporated embroideries with national emblems – such as wattle for Australia. Hartnell had first used embroideries of this kind in The Queen's Coronation Dress.

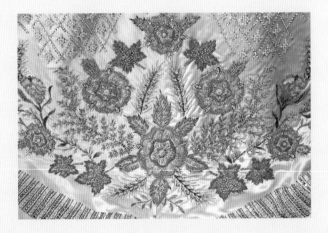

By incorporating these emblems, The Queen is able to pay a subtle and elegant compliment to the host nation. The choice of colour for evening gowns and daywear can also play an important role.

In Pakistan, during the tour of 1961, a dress worn for a State Dinner in Lahore was strikingly designed in ivory and emerald green duchesse satin, the national colours of the country. The Queen's couturier also has to consider the colours of the insignia of the country to be visited, to ensure that dresses and insignia do not clash, and fabrics are carefully selected to ensure that clothes are appropriate for the climate of the country visited. Hats must be neat and the brims 'off the face' to ensure that The Queen is visible at all times.

Each of the designers who have worked for The Queen have prepared dresses for her Commonwealth tours, notably Hartnell (1901–1979), Hardy Amies (1909–2003) and Ian Thomas (1929–1993).

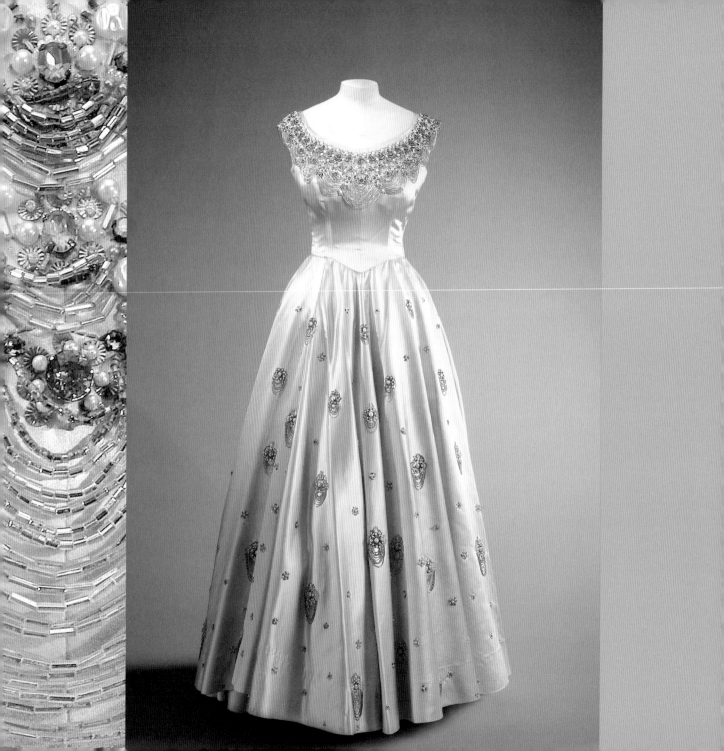

AFRICA

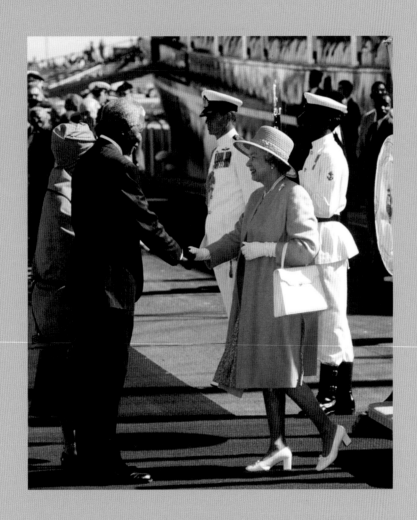

In February 1947 Princess Elizabeth paid her first visit to Africa, accompanying her father, King George VI, her mother Queen Elizabeth and her sister Princess Margaret on a royal tour of southern Africa which lasted nearly three-and-a-half months. During this time, the Princess celebrated her twenty-first birthday, in Cape Town on 21 April, where she made a broadcast in which she dedicated herself to the service of the people of the Commonwealth:

I declare before you that my whole life, whether it be long or short, shall be devoted to your service and the service of our great Imperial Commonwealth to which we all belong.

Princess Elizabeth and The Duke of Edinburgh were in Kenya in 1952 at the beginning of a Commonwealth tour when news of King George VI's death on

6 February reached them. The tour was immediately cancelled and the new Queen returned to London.

The Queen and Prince Philip have made eleven subsequent visits to African Commonwealth countries, beginning with the first Commonwealth Tour when they visited Uganda in April 1954. On this occasion The Queen opened the new Owen Falls Dam on the Nile, as it leaves Lake Victoria Nyanza. The Queen and The Duke of Edinburgh undertook a five-week tour of Africa in 1961, and in 1979 The Queen attended the Commonwealth Conference in Zambia. There have been four subsequent Commonwealth Heads of Government Meetings in Africa, most recently in Uganda in November 2007.

Among the gifts to Princess Elizabeth for her twenty-first birthday during the tour of southern Africa in 1947 was the magnificent diamond and platinum 'Flame lily' brooch from the children of Southern Rhodesia. The Flame lily (*Gloriosa superba*) was the national flower of Rhodesia.

In January and February 1956 The Queen and The Duke of Edinburgh paid a three-week visit to Nigeria. They attended a Durbar, including a 'Great Charge', held in their honour in Kaduna in Northern Nigeria, on 3 February. The climax of the 'Great Charge' occurs when the turbaned riders raise their swords and cheer for the royal visitors.

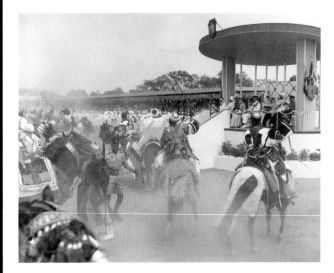

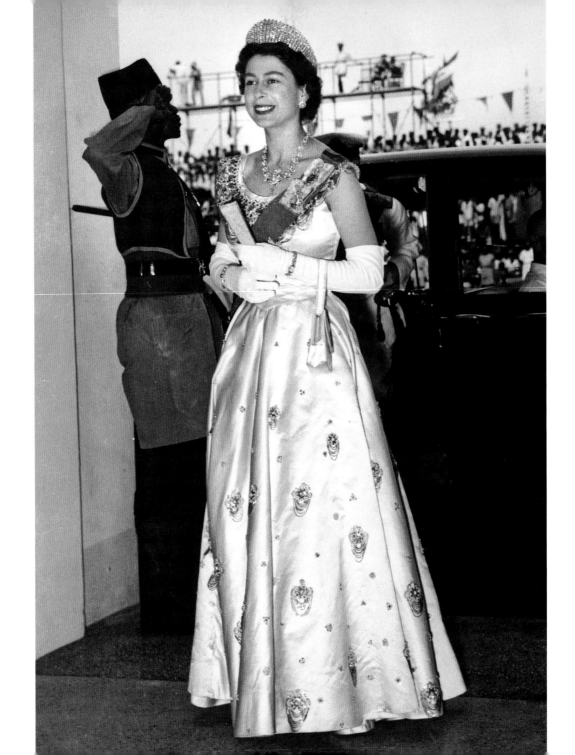

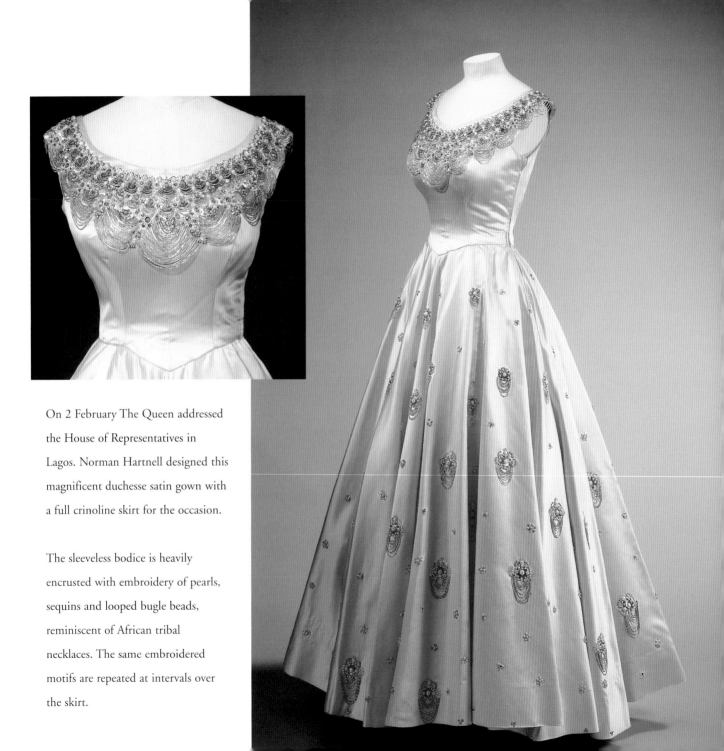

On 2 February The Queen addressed the House of Representatives in Lagos. Norman Hartnell designed this magnificent duchesse satin gown with a full crinoline skirt for the occasion.

The sleeveless bodice is heavily encrusted with embroidery of pearls, sequins and looped bugle beads, reminiscent of African tribal necklaces. The same embroidered motifs are repeated at intervals over the skirt.

During November and December 1961 The Queen and The Duke of Edinburgh undertook a tour of Africa, encompassing among other countries Ghana, Sierra Leone and Gambia. During this visit the Royal Yacht *Britannia* was used as their base, enabling the journeys between countries to be undertaken more easily.

During their ten days in Ghana, The Queen and The Duke visited the Central Region House of Chiefs, Cape Coast, who presented Her Majesty with a magnificent gilded carved wooden model of a Ghanaian royal procession (illustrated on page 4).

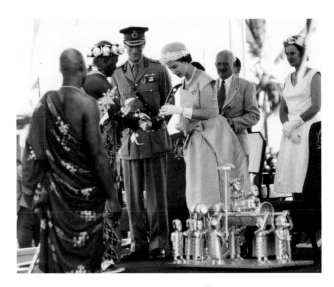

In Sierra Leone the royal visitors were entertained by traditional Susu dancers during an official visit to Port Loko on 4 December. The Queen was presented with an ivory lamp by the Bombali District, carved with the coat of arms of Sierra Leone.

The Ghanaian state gifts to The Queen included a traditional stool (Agua), symbolising 'Oman-keraa' (the soul of society). The seat of the stool is in the shape of a crescent moon (Oseramfa), symbolising the warmth of a mother's embrace. The same shape can be seen in this carved wooden stool, also from Ghana, presented to The Queen by Otumfuo Opoku Wareii Asantehene, King of the Ashanti, in 1972.

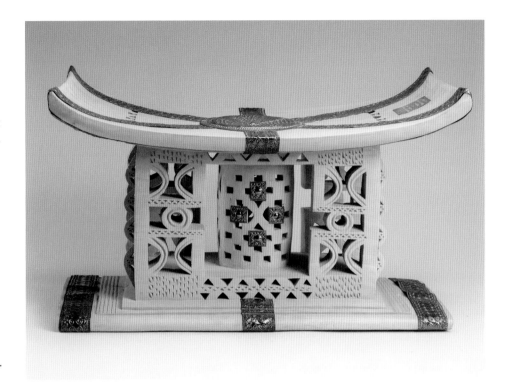

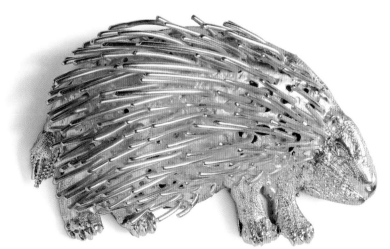

On the same occasion the King of the Ashanti presented The Queen with this gold brooch in the form of a Kotoko porcupine.

Twenty years after her accession to the throne, The Queen revisited Kenya in March 1972. During the visit she was invested with the Order of the Golden Heart by President Jomo Kenyatta, seen here with The Queen and Mrs Kenyatta in Nairobi.

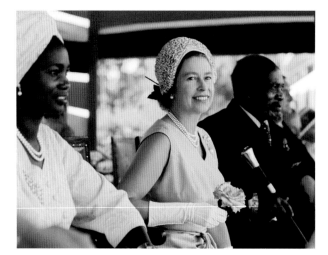

In July 1979 The Queen and The Duke of Edinburgh attended the Commonwealth Conference in Lusaka, Zambia. The conference was combined with visits to Malawi and Botswana. During the visit the President of Botswana presented The Queen with a woollen wall hanging depicting daily life in Botswana.

In November 1983 The Queen returned to Kenya as the guest of President Daniel Arap Moi, who gave her this marble sculpture of an eagle.

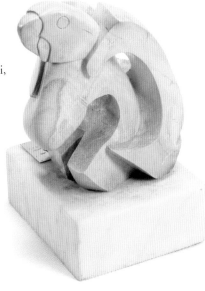

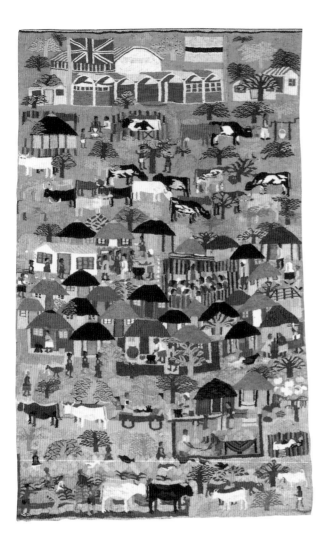

Part of The Queen's duty as Head of the Commonwealth is to receive heads of Commonwealth countries during state visits to the United Kingdom. During her reign she has hosted seventeen such visits. In 1985 she received the President of the Republic of Malawi at Windsor Castle.

During this visit the President presented The Queen with a traditional Malawian carving, carved by an eighteen-year-old sculptor, Wilson Tibu. 'Chauta's Family', carved from sausage-tree wood, expresses unity and peace, cardinal virtues for the people of Malawi and an expression of the warm heart of Africa.

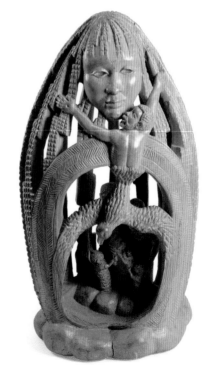

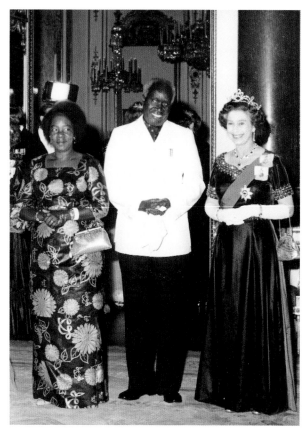

In 1983 The Queen received
a State Visit from President
and Mrs Kaunda of Zambia,
seen here in the Music Room
at Buckingham Palace.

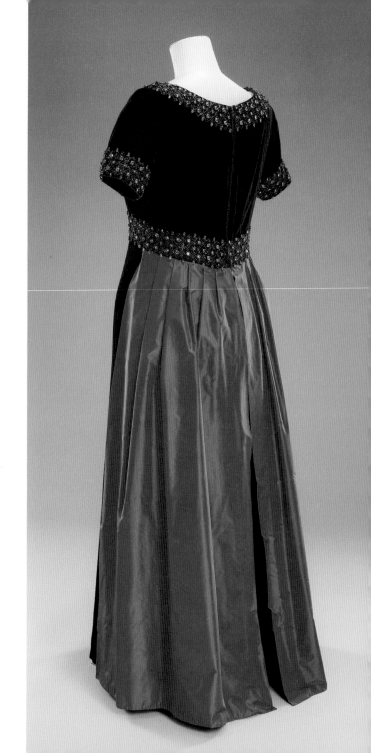

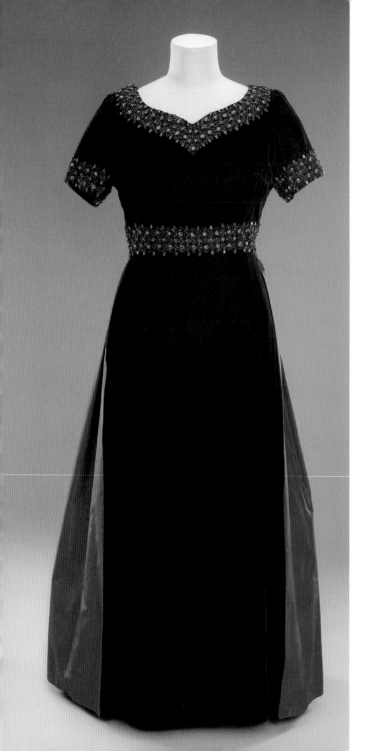

For the State Banquet The Queen wore this deep blue silk-velvet evening dress, designed by Ian Thomas. Thomas trained with Norman Hartnell and established his own couture house in 1970. When he began to design dresses for The Queen, he introduced new shapes and softer, flowing lines for evening dresses, often combined with bright and daring colours.

This striking dress incorporates two panels of blue taffeta which fall into an elegant train from the back of the waist.

The embroidery of diamanté, sequins and bugle beads around the neckline, sleeves and waist is designed to catch the twinkling evening light of a state banquet.

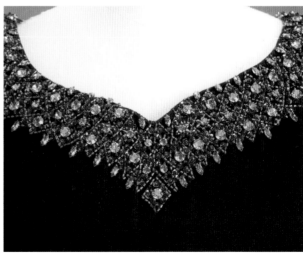

In 1994, The Duke of Edinburgh had represented The Queen at the official inauguration of President Mandela in Pretoria on 10 May, and in March 1995 The Queen paid an historic visit to South Africa at the invitation of President Mandela – her first visit for 48 years and her first as Head of State.

The welcome given to The Queen and The Duke of Edinburgh as they alighted from *Britannia* in Port Elizabeth was extraordinary. In her speech at the State Banquet held in her honour in Cape Town on 20 March, Her Majesty recalled her first visit in 1947 with her parents and her sister:

I have much enjoyed in recent weeks refreshing my happy memories of our journey, not least of celebrating my twenty-first birthday here in Cape Town. I recall the beauty of this land, its variety and the rich tapestry of the peoples we met as we crossed the country by land, sea and air.

The visit was particularly significant since it celebrated the return of South Africa to the Commonwealth after thirty-two years' absence, an event which had been marked in London in June 1994.

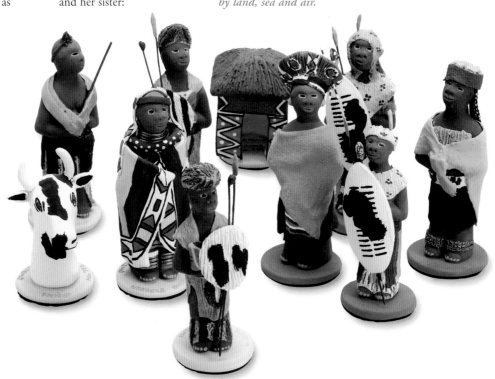

The Queen was also presented with the Grand Cross of the Order of Good Hope by President Mandela.

President Mandela made a State Visit to the United Kingdom in November 1996, where he presented this hand-painted chess set to The Duke of Edinburgh. The figures represent people of the Zulu and Ndebele tribes in traditional costume.

In November 1999 The Queen and The Duke of Edinburgh attended the Commonwealth Heads of Government Meeting in South Africa. Her Majesty attended a prize-giving for a British Council essay competition in Pretoria. The Queen wore this pink, white and grey chiffon day dress, designed by Maureen Rose Couture. Maureen Rose worked for Ian Thomas for a number of years until his death in 1993, after which she continued to design clothes for The Queen.

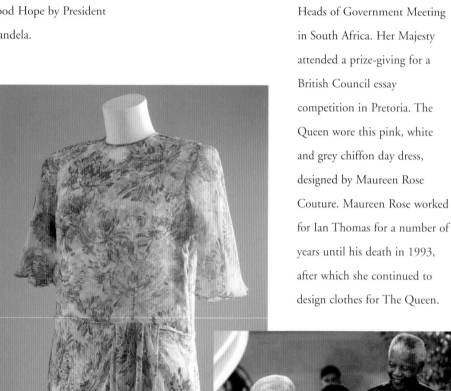

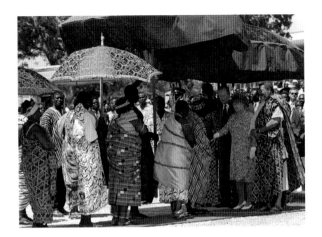

The dress is of very fine silk, chosen for its suitability for the hot climate, and is printed with pink and yellow daisies.

The wide-brimmed silk hat is trimmed with silk in the same design as the dress.

The Queen also visited Ghana and Mozambique in November 1999, where she met Chiefs of Tribes during a Durbar in Accra, Ghana. On this occasion she wore a silk day dress by John Anderson.

John Anderson worked for both Norman Hartnell and Hardy Amies before establishing his own business with Carl Ludwig Rehse in 1988, at which time he began to design for The Queen.

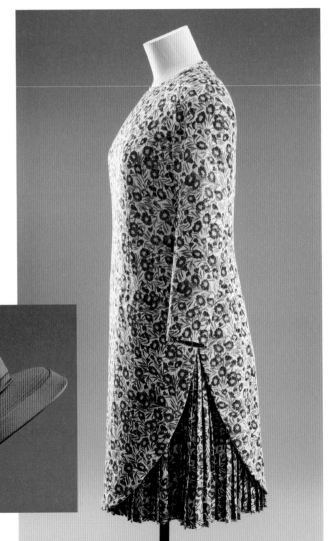

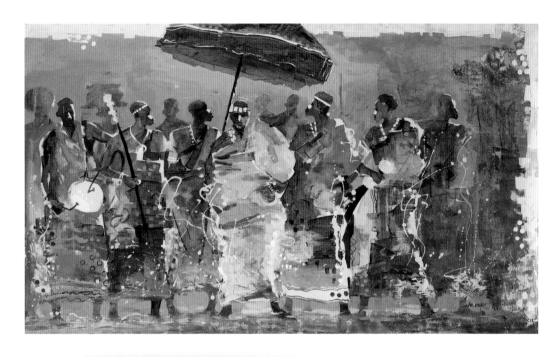

Many thousands of loyal addresses and addresses of welcome have been presented to The Queen on Commonwealth tours. An address of welcome, in the form of a Kente cloth, was presented by Mr Anthony Kwadwo Gyasi in 1998.

This painting by Robert Aryeetey, entitled *Royal Pageant*, was presented to Her Majesty by the Chiefs and people of Ghana during the same visit.

In December 2003 The Queen attended the Commonwealth Heads of Government Meeting in Abuja, Nigeria. On the second day of her visit she toured the village of Karu wearing this dress and jacket of salmon-pink silk with rose sprigs.

The elegant matching hat, of asymmetric design in fine straw trimmed with feather quills, was designed by Philip Somerville. Somerville worked with Otto Lucas as a millinery designer before establishing his own business. He began to provide hats for The Queen under Ian Thomas's label and, from 1988, under his own name. He became a Royal Warrant Holder in 1994.

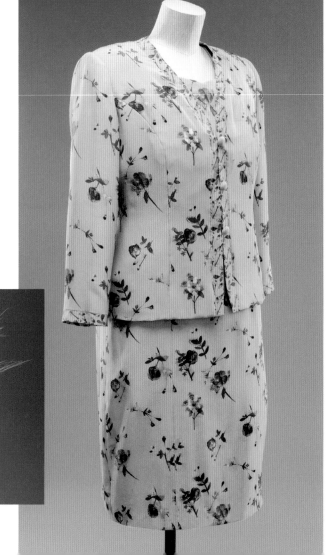

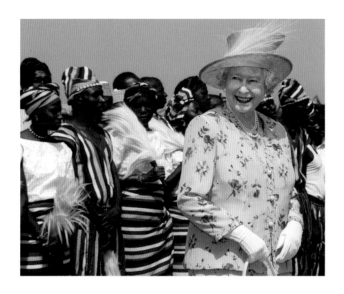

During the most recent visit to Africa, to attend the Commonwealth Heads of Government Meeting in Kampala, Uganda, in November 2007, The Queen and The Duke of Edinburgh undertook a full programme of visits, including one to the Mildmay International Centre for AIDS orphans, where the children performed a fashion show of their own designs.

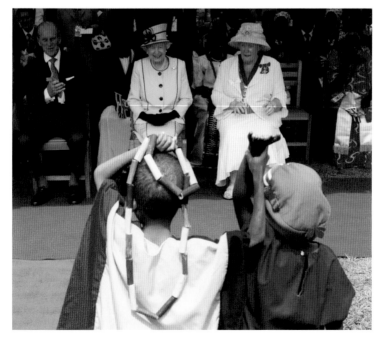

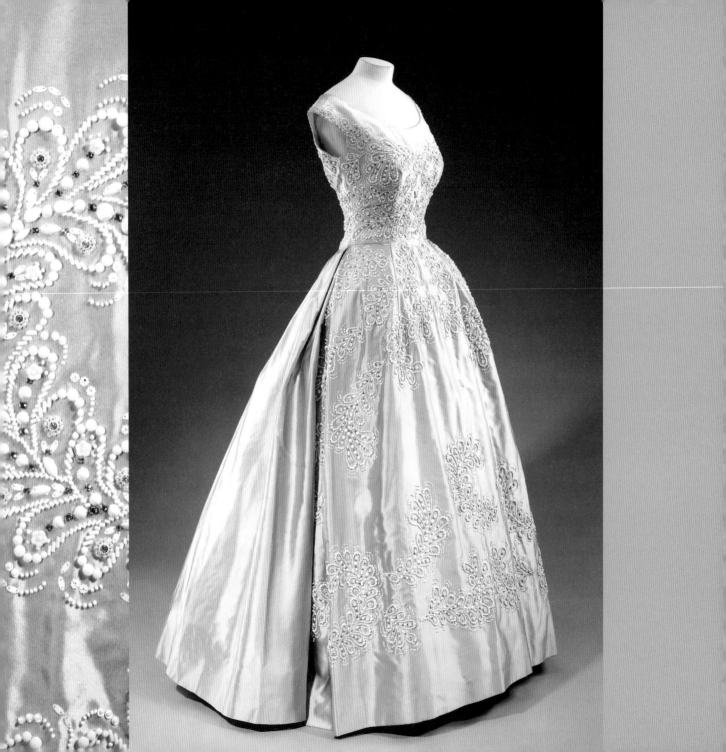

ASIA

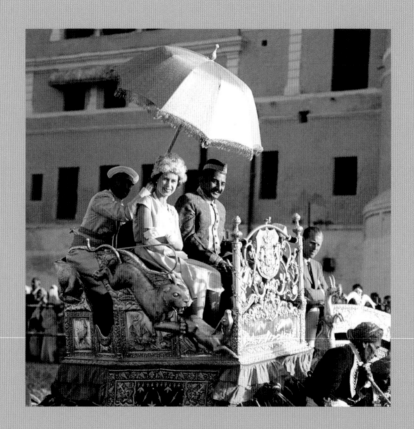

During The Queen's first visit to Asia in April 1954, she spent ten days in Ceylon (now Sri Lanka). She opened Parliament in Colombo, wearing her Coronation Dress, for the third and final time during the tour, in fierce tropical heat, and witnessed a spectacular procession, or Raja Perahera, in Kandy, involving 140 richly decorated elephants, before a crowd of over a million people. One of the more unusual gifts she received was a native palm tree (*Corypha umbraculifera*), presented at the Royal Botanic Gardens at Peradeniya. The tree was transported back to the Royal Botanic Gardens, Kew. From the Municipal Corporation of Delhi, she received an ivory and ebonised wood model of the famous Qutb Minar – the world's tallest brick minaret. The Queen returned to Sri Lanka almost thirty years later in 1981. In early 1961 The Queen returned to Asia for a six-week tour of India and Pakistan. This visit encompassed virtually the length and breadth of both countries. In November 1983

The Queen paid a State Visit to Bangladesh and India, where she also attended the Commonwealth Heads of Government Meeting in New Delhi. She returned to India and Pakistan in October 1997, to mark the fiftieth anniversary of Indian independence, an event which had encouraged the formation of the modern Commonwealth. The Queen undertook a tour of Singapore, Malaysia and Brunei in 1972, returning in 1989 for a State Visit to Singapore and Malaysia and the Commonwealth Heads of Government Meeting in Kuala Lumpur. In 1998 she visited Malaysia to officially close the XVI Commonwealth Games and her most recent visit to the region was to Singapore in March 2006.

During the six-week tour of
India and Pakistan, from
21 January to 2 March 1961,
The Queen and The Duke of
Edinburgh were the guests
of President Rajendra Prasad
of India, and President Ayub
Khan of Pakistan.

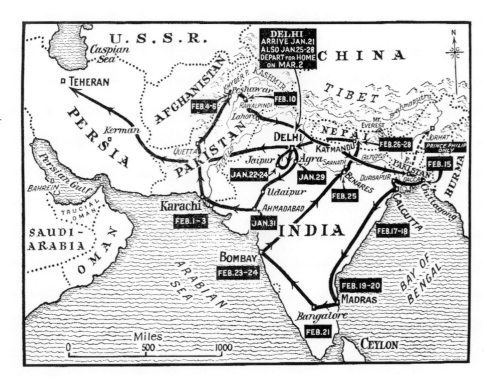

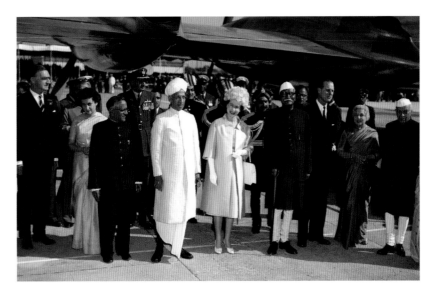

The Queen's personal flag
was flown for the first time
on the BOAC *Britannia*, in
which she landed at Delhi
airport on 21 January.

41

The tour encompassed all the major cities of both countries. On the first evening of the visit, President Prasad gave a State Banquet in The Queen's honour, for which she wore this pearl-encrusted evening dress designed by Norman Hartnell.

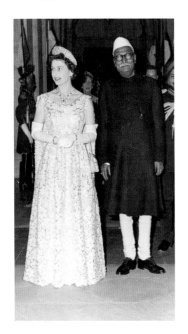

The dress is made of fine lace, richly embroidered with pearls, sequins and bugle beads in a design of lotus flowers – the national flower of India. The dress originally had a train falling from the shoulders, but this was subsequently altered and made into a matching bolero jacket.

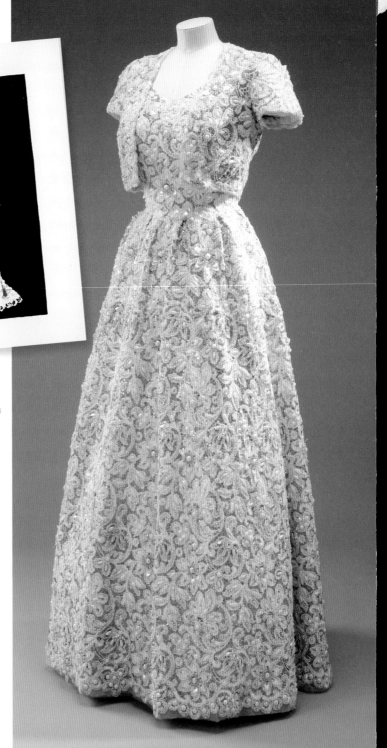

The Queen addressed a crowd, estimated to number a quarter of a million, at Ramlila Grounds, before attending a Civic Reception with the Prime Minister.

Among the many gifts presented during this tour was a pair of brass oil lamps from the Government of Madras.

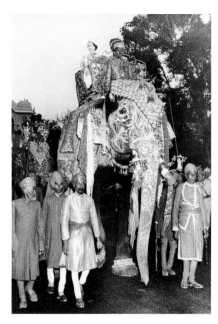

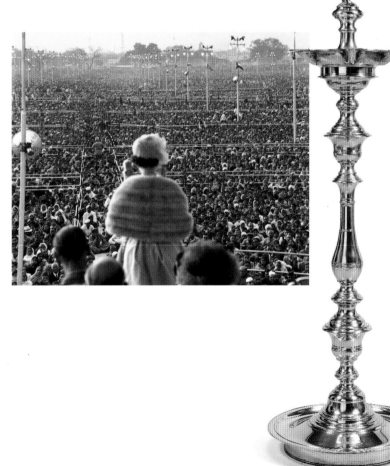

The Queen twice rode by elephant during this visit – once to the City Palace at Bakrota and, while in Benares, in an elephant procession to Balua Ghat.

On their first day in Pakistan, The Queen and Prince Philip attended a banquet given in their honour by President Ayub Khan at his residence in Karachi. A great deal of careful thought and planning went into The Queen's wardrobe for this tour, particularly the grand evening dresses worn on important state occasions.

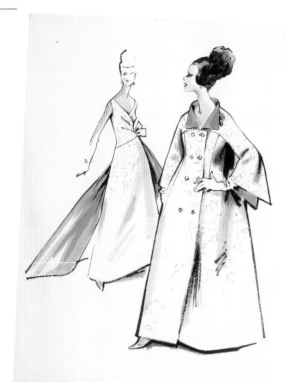

For this banquet, The Queen wore a duchesse satin evening dress in ivory and emerald green – the national colours of Pakistan. Norman Hartnell, who designed the dress, incorporated a dramatic waterfall train at the back.

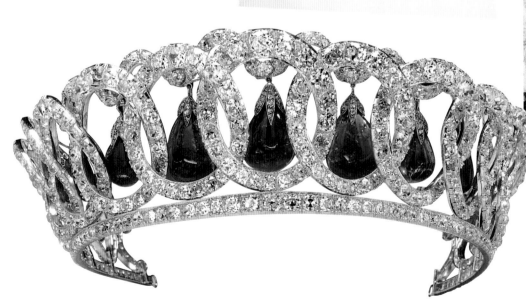

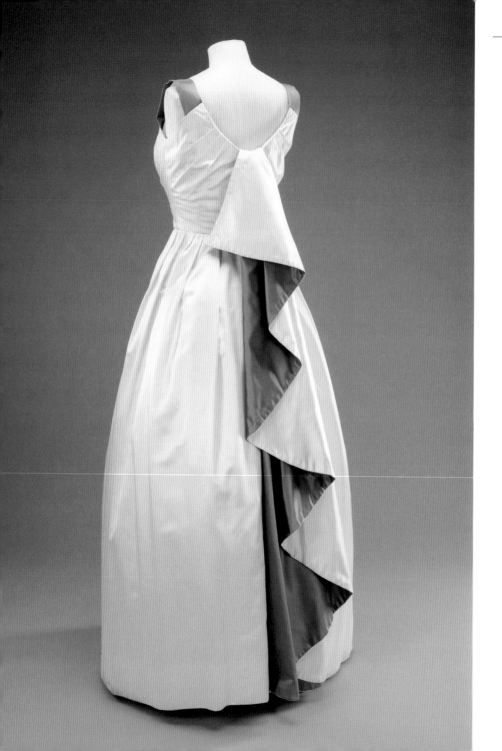

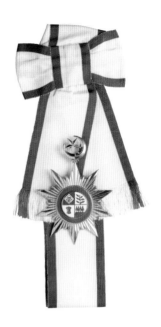

The dress was the perfect foil for The Queen's insignia of the Order of Pakistan, with which she was invested by President Ayub Khan during her visit. To add to the dazzling effect, Her Majesty wore the Vladimir Tiara, hung with the Cambridge emeralds.

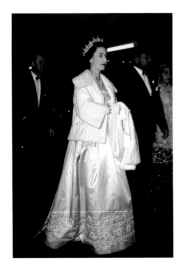

flowers in subtle shades of gold, silver and pearl, highlighted by iridescent sequins, seed pearls and bugle beads. A detachable train is applied to the bodice and terminates in a panel of the same embroidery. Unlike Hartnell, who had a workshop dedicated to his sumptuous embroideries, Hardy Amies used Lock and Co. for the embroidery of his gowns.

The number of dresses required for the tour was considerable. In addition to those designed by Norman Hartnell, The Queen also wore dresses designed by Hardy Amies. For a dinner given by the Governor of Lahore on 10 February, Amies designed a dress of pale yellow duchesse satin, embroidered with stylised

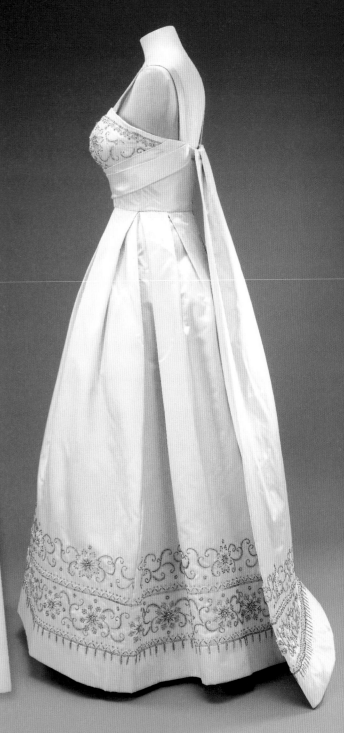

The following evening, The Queen and The Duke of Edinburgh attended a dinner given by the Commander-in-Chief of the Pakistan Army, for which Her Majesty wore a magnificent crinoline gown of pale blue silk faille, embroidered all over with white beads in a feather motif. This dress was designed by Hartnell, who favoured this combination of colours.

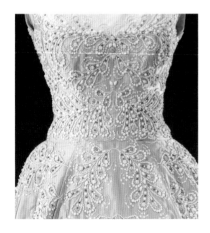

Among Her Majesty's many other engagements was a ladies' reception at the State Guest House, Karachi; meetings with Commonwealth High Commissioners, and with Tribal Maliks in Quetta; a visit to the Khyber Pass; and attendance at a Girl Guides Rally at the Lahore Fort, at which she was presented with a loyal address in this silver container.

Following a reception for the Citizens of Chittagong, on 15 February, The Queen was presented with this silver model of an elephant.

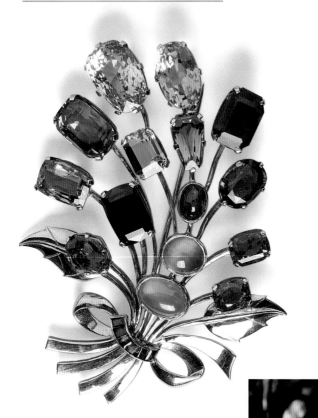

During The Queen's State Visit to Sri Lanka in October 1981, the Mayor of Colombo presented her with a brooch in the form of a flower spray in gold, set with precious and semi-precious stones including sapphires, rubies and diamonds.

The Queen returned to India on a State Visit in November 1983 as the guest of the Prime Minister, Mrs Indira Gandhi. While in India she attended the Commonwealth Heads of Government Meeting in New Delhi.

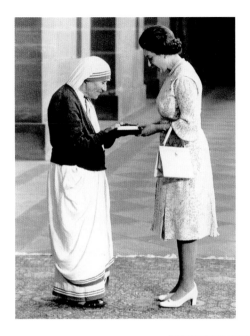

During her visit, in a special ceremony at the Rashtrapati Bhavan, The Queen invested Mother Teresa of Calcutta as an Honorary Member of the Order of Merit.

The Queen has travelled by many different forms of transport during her Commonwealth visits and while in India she was carried in a 'Palki' – a type of sedan chair.

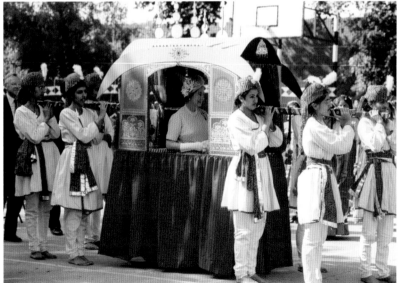

In 1997 The Queen and The Duke of Edinburgh paid a State Visit to Pakistan and India to mark the fiftieth anniversary of Indian Independence. During a speech given at the State Banquet in New Delhi on 13 October, The Queen spoke of India's vital contribution to the Commonwealth:

Like Britain, India has always been a country which is open to other cultures, and able to accept and assimilate them in a constructive way. This is one of the many reasons why India is such a vital and distinguished member of the Commonwealth.

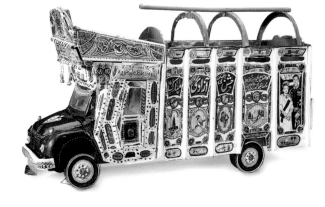

During their visit, The Queen and Prince Philip visited the Golden Temple at Amritsar, where they were presented with this model of the temple, in painted wood and gold leaf.

The Queen was also presented with this painted truck by the High Commission drivers.

In February and March 1972 The Queen and The Duke of Edinburgh undertook a tour of Singapore, Malaysia and Brunei. They flew to Singapore where they joined the Royal Yacht *Britannia*, used as their residence throughout the visit.

During the visit to Malaysia The Queen wore this bright green silk-crêpe day dress, designed by Norman Hartnell. The light fabric and simple design were ideal for the climate.

The striking hat was designed by Simone Mirman, and is of a cloche shape in fine net, decorated all over with fabric flowers. This style of hat was much favoured by The Queen in the 1960s and 1970s. Mirman trained in Paris and moved to London to become head milliner to Schiaparelli. During the Second World War she established her own company and made hats for Queen Elizabeth The Queen Mother and Princess Margaret before Hartnell introduced her to The Queen, for whom she made hats for over two decades.

During the tour of Malaysia
and Singapore, The Queen
wore this striking dress,
designed by Norman
Hartnell. The dress is of
white plush velvet with a
light red floral design. The
skirt has an integral train and
the waist is highlighted at the
rear by a thick red velvet sash
tied in a soft bow.

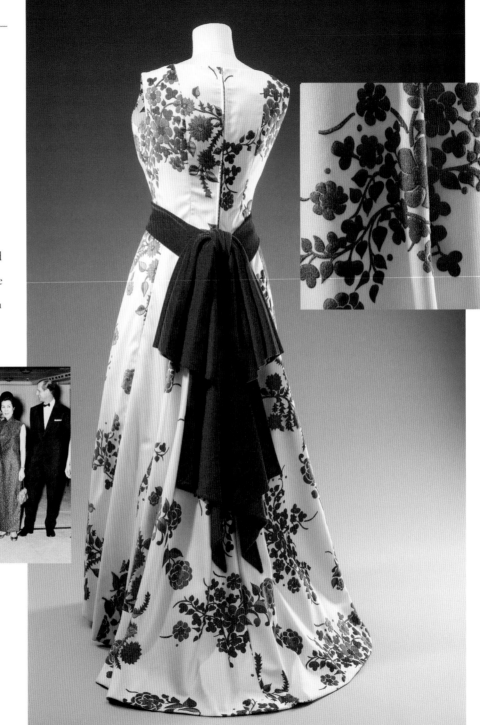

An orchid, *Dendrobium Elizabeth*, was named after The Queen while she was in Singapore. On the occasion of Her Majesty's Golden Jubilee in 2002 the President of the Republic and the Government and People of Singapore presented her with a gold model of the flower.

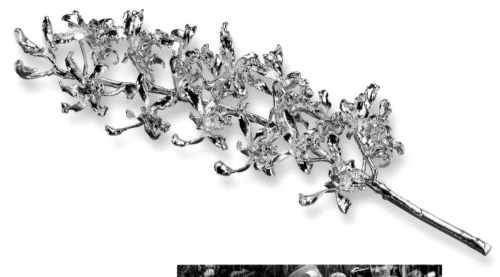

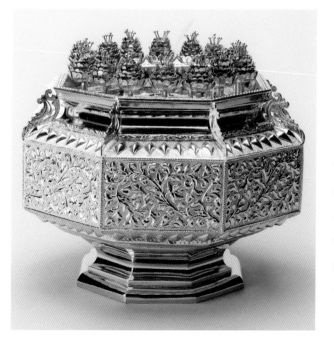

The Queen paid her first visit to Brunei as part of this tour, as the guest of the Sultan, who presented her with this gold box decorated with pine cones.

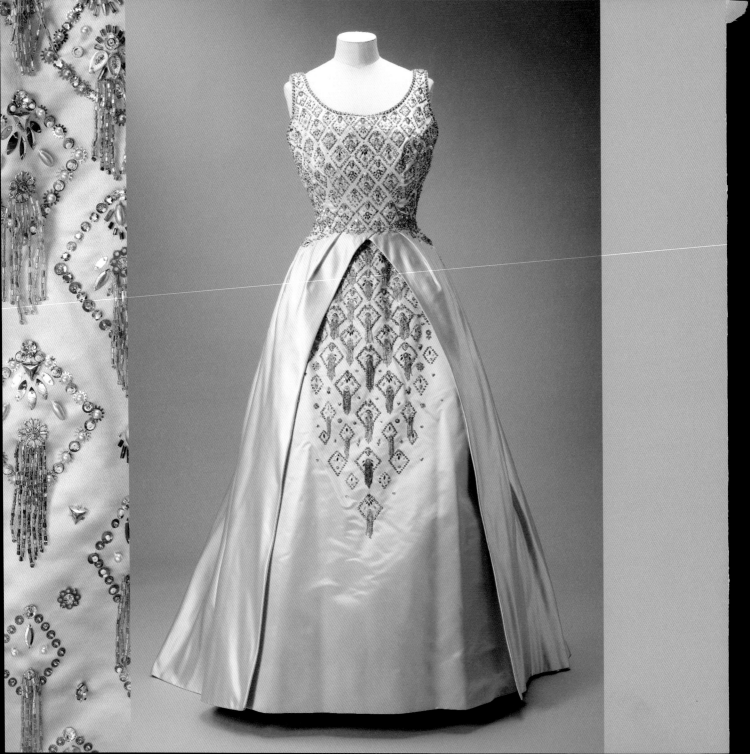

AUSTRALIA
AND
NEW ZEALAND

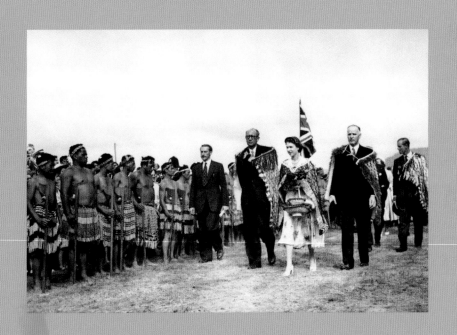

As constitutional monarch of Australia and New Zealand, The Queen has an important ceremonial and symbolic role in both countries. Together with The Duke of Edinburgh she has paid 15 separate visits to Australia over the last 58 years. The Queen is the first reigning monarch to visit Australia, first setting foot on Australian soil on 3 February 1954, when the SS *Gothic* steamed into Sydney Harbour, watched by hundreds of thousands of well-wishers who had turned out in small craft of all types to witness her historic arrival. In 1963 The Queen returned to Australia for a month-long tour, visiting each state and celebrating the fiftieth anniversary of the capital, Canberra. Seven years later, in March 1970, The Queen and Prince Philip returned to join the celebrations marking Captain James Cook's discovery of Australia 200 years earlier. In 1973 The Queen opened Sydney Opera House and in 1977 undertook

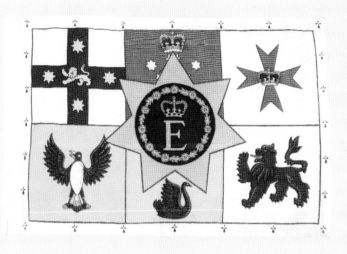

a three-week tour encompassing each state. In the 1980s The Queen and The Duke of Edinburgh visited on five separate occasions, including attending the 1981 Commonwealth Heads of Government Meeting in Melbourne, the Commonwealth Games in 1982 and Australia's bicentenary celebrations in 1988. In 2002 she visited Brisbane, Adelaide and Cairns as part of her Golden Jubilee celebrations. The Queen's most recent visit was undertaken in 2006.

The first visit to Australia was remarkable in its scope, encompassing every state and every major city, with parliament openings, investitures, state banquets, balls, garden parties, children's gatherings, hospital visits and traditional Aboriginal dances. The Queen attended race meetings and cricket matches, made a visit to the flying doctor service in the Outback, experienced natural wonders such as the Great Barrier Reef, and even attended a surfing carnival on Bondi Beach.

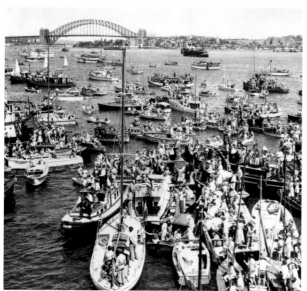

The Queen and The Duke of Edinburgh travelled thousands of miles by air, sea, rail and road. During the long voyages, the *Gothic*'s escort ship was HMAS *Australia*, which The Queen and Prince Philip inspected during their visit to Cairns.

Many extraordinary gifts were received by the couple, from traditional Aboriginal craftsmanship in the form of boomerangs and didgeridoos, to a bale of wool from the Australian Wool Board, and daffodil bulbs from the National Daffodil Society of Tasmania.

For her tour of Australia and New Zealand The Queen took over one hundred dresses with her. Great attention was paid to ensure that for each of the most prominent events, such as the parliament openings and grand balls, The Queen would not be seen in the same dress more than once.

On 23 March 1954, the people of South Australia gave The Queen the 'Andamooka' Opal as a token of their loyalty and affection. The opal weighs 203 carats and was found at the Andamooka Opal Fields, west of Oodnadatta, South Australia, in 1949. It is said to be the finest-quality opal ever found in the Andamooka Fields, partly because of its size (the rough stone from which it was cut measured 10 x 5 cm), but also because of the intensity of the fire and flashes of colour in the stone. The complete suite of jewellery, designed and made by Wendts Limited of Adelaide, consists of the necklace with matching earrings, set in palladium, and diamonds in a scroll design.

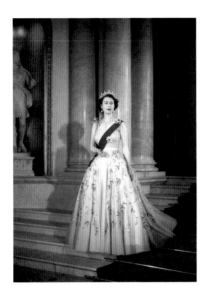

A magnificent crinoline gown decorated with sprays of wattle, the national flower of Australia, was worn by The Queen for a state banquet in Sydney. The Queen is depicted wearing this dress in the Australian State portrait, painted by Sir William Dargie in 1954. It is the most familiar image of The Queen in Australia, displayed at Government House, Canberra. This version was presented by the Government of Australia to The Queen during her tour of Australia in 1954.

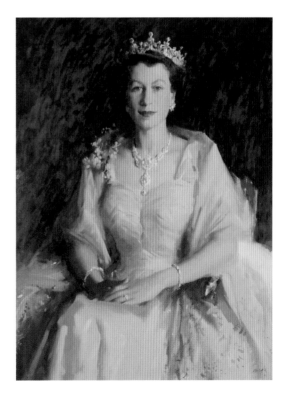

Women all over the country became more and more fascinated by The Queen's clothes as her tour progressed. Norman Hartnell, who designed a good number of the dresses, particularly the evening gowns, showed great skill and attention to detail in the careful selection of fabrics, bearing in mind both the climate, and the choice of colours – always selecting those which would allow The Queen to be clearly visible at the vast gatherings she attended. Hartnell was already aware of the significance of national colours and emblems when designing 'grand occasion' wear for The Queen, and in the dresses for the first Commonwealth tour he produced some of his finest royal couture.

On her first visit in 1954, The Queen's state gift from the Government and People of Australia was a diamond brooch in the form of a spray of wattle. It was made by William Drummond & Co. of Melbourne.

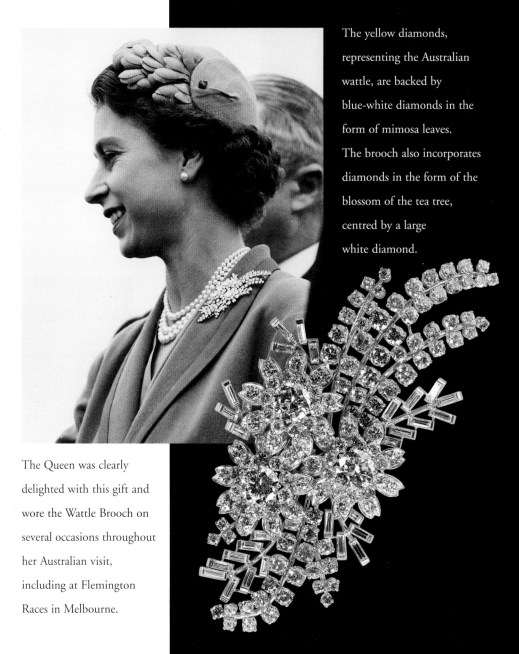

The yellow diamonds, representing the Australian wattle, are backed by blue-white diamonds in the form of mimosa leaves. The brooch also incorporates diamonds in the form of the blossom of the tea tree, centred by a large white diamond.

The Queen was clearly delighted with this gift and wore the Wattle Brooch on several occasions throughout her Australian visit, including at Flemington Races in Melbourne.

For The Queen's 1974 visit to Australia, Ian Thomas repeated the use of the wattle emblem for one of Her Majesty's dresses. The dress is of mimosa yellow silk chiffon, the sleeveless shift terminating in a bias cut skirt and with a matching shoulder cape.

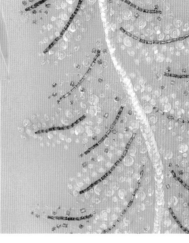

The dress is embroidered overall with sprigs of wattle in iridescent sequins, and knotted yellow and orange silk, and the foliage is picked out in green bugle beads.

In the event, due to the General Election, the tour was cut short and The Queen did not wear the dress while in Australia.

From her earliest to her most recent visits to Australia, The Queen has received numerous examples of traditional Aborigine craftsmanship, including boomerangs, didgeridoos and carved wood figures.

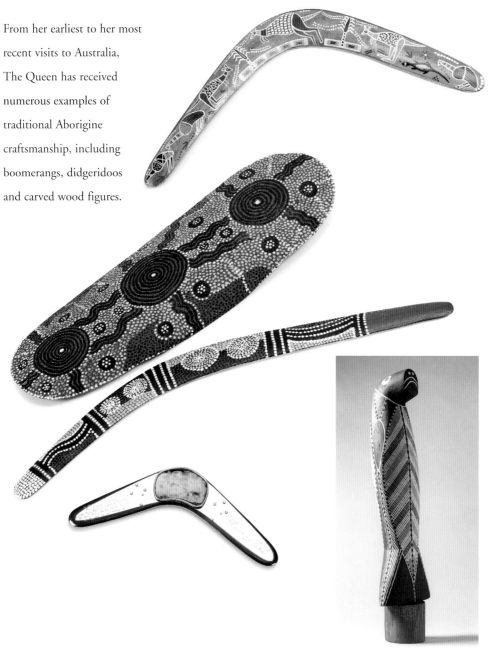

Shown here are a boomerang painted with hunting scenes, which was presented on the occasion of the children's welcome at Perry Lakes Stadium, 1963; a boomerang and shield presented by Billy Stockman; and a silver boomerang set with an opal by Kenneth Mansergh, presented in 1992. In 2000, the Governor-General of Australia, Sir William Deane, presented a carving of a dugong (sea cow) by the artist Stephen Kawurlkku.

For the bicentennial celebrations of the discovery of Australia in 1970, The Queen and The Duke of Edinburgh undertook a six-week tour of Australia and New Zealand. During the tour The Queen enjoyed a visit to Randwick Racecourse near Sydney, where she spoke to some of the jockeys about to take part in the Queen Elizabeth Stakes, specially named in her honour.

On this occasion she wore a dress, coat and hat of mimosa yellow. The sleeveless dress and coat, designed by Norman Hartnell, is of fine wool crêpe, applied with contrasting cream-coloured bands of the same fabric.

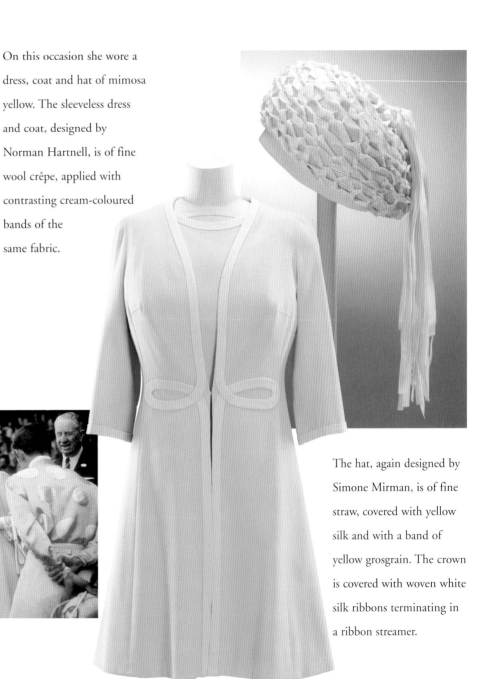

The hat, again designed by Simone Mirman, is of fine straw, covered with yellow silk and with a band of yellow grosgrain. The crown is covered with woven white silk ribbons terminating in a ribbon streamer.

In 1973 The Queen made a
special visit to open Sydney
Opera House, which had
been designed by the Danish
architect Jørn Utzon. For the
concert on the evening of the
official opening, The Queen
wore a dress of white silk
with gold and silver
embroideries, reflecting the
outline of the new building.

On this occasion, the
Premier of New South Wales,
Sir Robert Askin, presented
The Queen with a painting
by Fred Williams of Sydney
Opera House and Harbour
Bridge.

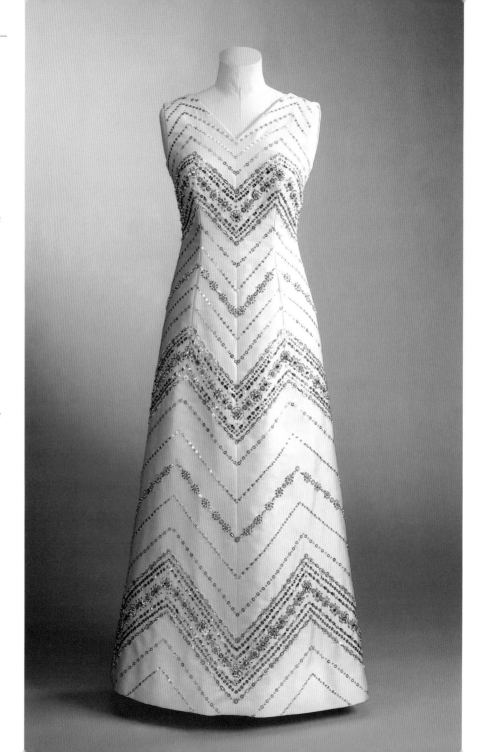

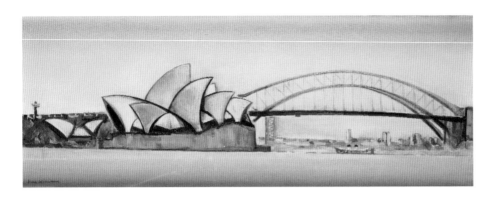

During the Silver Jubilee tour The Queen and The Duke of Edinburgh spent three weeks in Australia visiting each state. On a visit to Melbourne Zoo, The Queen wore this dress and jacket designed by Ian Thomas.

In February 1975 The Queen instituted the Order of Australia, of which she is Sovereign.

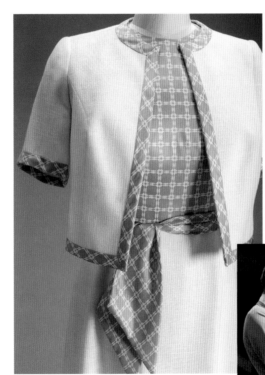

The dress has a bodice of caramel-coloured silk with a white geometric design, while the skirt is of white linen to match the short-sleeved jacket, which is trimmed in the silk of the dress.

The Queen and The Duke of Edinburgh paid their first visit to New Zealand in 1953, during the first Commonwealth tour. Her Majesty was the first reigning monarch to open the New Zealand Parliament, in Wellington, wearing her Coronation Dress for the second time on this tour. During the visit The Queen met Maori Chiefs at Arawa Park, Rotorua, and was invested as a Maori chieftain with the traditional feather cloak. The Queen and The Duke of Edinburgh returned ten years later, in February 1963, during a tour of Australasia, and again in March 1970, with The Prince of Wales and Princess Anne, to celebrate the bicentenary of Captain Cook's voyages. In February 1974 The Queen attended the Commonwealth Games in Christchurch, which she officially closed on 2 February.

The Queen visited New Zealand again at the start of her Silver Jubilee tour in February and March 1977, and in 1990 visited Wellington, Christchurch and Auckland, where she attended the XIV Commonwealth Games. In November 1995 The Queen attended the Commonwealth Heads of Government Meeting in Auckland, and her most recent visit was in February 2002, for the Golden Jubilee celebrations.

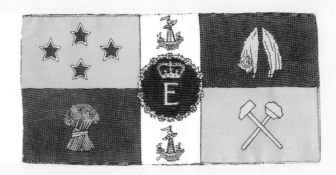

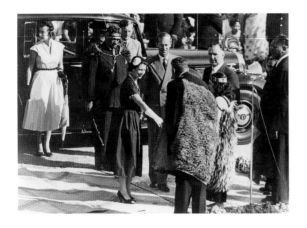

She made special reference to the achievements of Sir Edmund Hillary, referring to the news she had received on the eve of her Coronation of his conquest of Mount Everest. During her tour, The Queen visited Hillary's home town, Papakura, and Timaru City Council presented The Queen with a tapestry depicting Mount Cook ('Aoraki', meaning 'Cloud-Piercer', in Maori), which had been used as the training ground for the Everest Expedition.

The Queen first set foot in New Zealand when she arrived in Auckland in December 1953. During this visit, she toured both Islands and spent Christmas Day at Government House where she made her Christmas Broadcast to the Commonwealth. In this she spoke of her voyage around the world, her desire to see as much as possible of the people and countries of the Commonwealth, and how impressed she was with the achievements and opportunities which the modern Commonwealth presented.

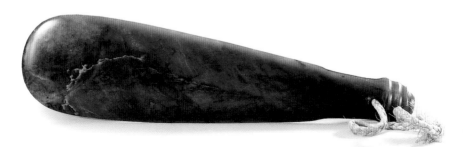

In 1963 The Queen was presented with a greenstone Mere entitled 'Budding Cloud' ('Kapua Wha Karito'), from Chief Paora Rerepu Te Urupu.

On Christmas Day 1953, the 'Women of Auckland' presented gifts to The Queen and The Duke of Edinburgh for themselves and for Prince Charles and Princess Anne. The Duke of Edinburgh received a gold pen and pencil, Prince Charles an electric train, and Princess Anne a walking doll with pram and wardrobe. The Queen was given a magnificent diamond and platinum brooch in the form of a spray of Silver Fern, an important national emblem in New Zealand. The Queen wore the brooch on several occasions throughout her first visit to the country.

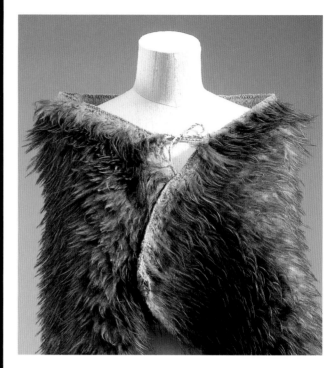

Later during the 1953 tour, The Queen arrived in Rotorua, one of the great centres of Maori tradition and culture, where the tribes had assembled in force. The traditional welcome included the 'Haka Haka' and a 'Poi' song, sung by Maori girls. At Arawa Park the royal couple were presented to Maori chiefs and given Maori feather cloaks ('Kahu Kiwi') of brown Kiwi feathers and flax capes ('Korowai') covered in 'hukahuka' tassles.

The kiwi bird holds a special significance for the Maori. For them, it is symbolic of their elder brothers and sisters, who represent protective spirits. Cloaks of kiwi feathers are worn to symbolise chieftainship and high birth and are used at significant moments in life, including official ceremonies. The Queen and The Duke of Edinburgh have often worn their feather cloaks on subsequent visits to the country, notably for the commemoration of the 150th anniversary of the Treaty of Waitangi in 1990.

The Queen was also presented with a carved wooden box containing feathers and decorated with shell.

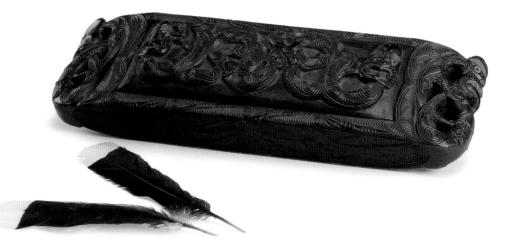

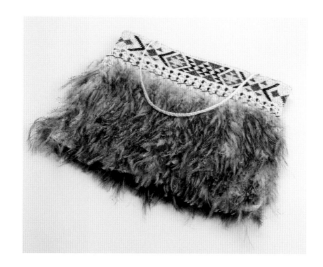

During a visit to New Zealand in October 1981, the Te Atiawa people of Waiwhetu presented The Queen with this bag made of flax and kiwi feathers.

This elegant evening dress of gold lamé overlaid with cream-coloured lace, re-embroidered in gold thread, was worn by The Queen for an investiture in Wellington. It was designed by Norman Hartnell, who prepared the majority of the dresses for this first Commonwealth tour.

Among the many natural wonders which The Queen and The Duke of Edinburgh saw during their tour of 1953–4 were the hot springs and pools of boiling mud at the Whaka Thermal Reserve, where they were guided by the famous Maori guide 'Rangi' – Mrs Rangitiaria Dennan.

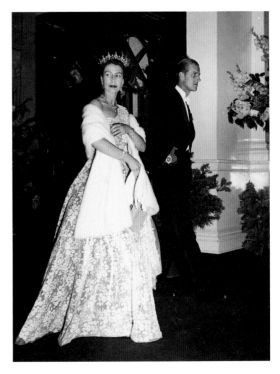

Hartnell's forte, apart from exquisite embroideries, was his re-introduction of the crinoline skirt, of which this dress is a fine example. This grand dress is typical of the evening gowns worn by The Queen during her first visit to Australia and New Zealand.

71

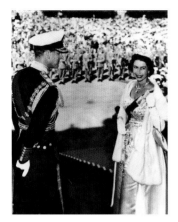

On 12 February 1963
The Queen opened the third
session of the Thirty-Third
Parliament in Wellington.
She wore this elegant dress
of oyster duchesse satin
embroidered with pearls,
beads, bugle beads, diamanté
and sequins in a diamond
pattern, with bugle beads
forming tassel drops,
alternately in silver and gold.
The bodice is embroidered in
its entirety and the scissor-cut
skirt reveals further
embroidery underneath.

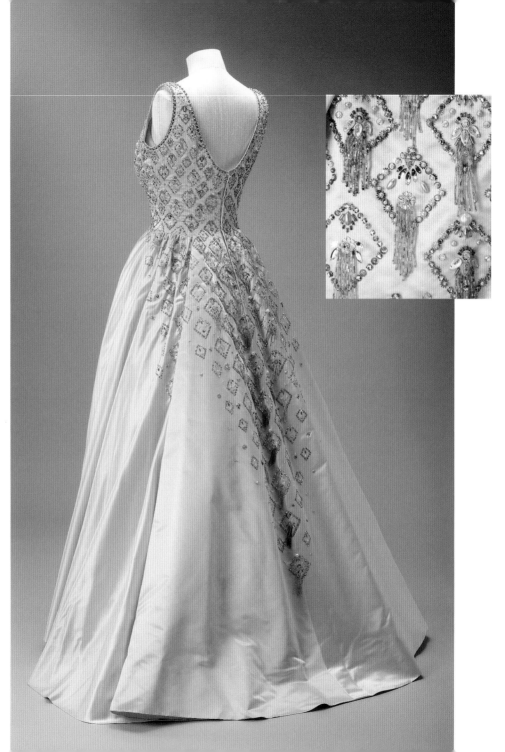

On 9 January 1974, at Sandringham House, The Queen started the relay for the Commonwealth Games. The Queen, Patron of the British Commonwealth Games Federation, and The Duke of Edinburgh (then President of the Federation) were present in Christchurch at the official close of the Games on 2 February.

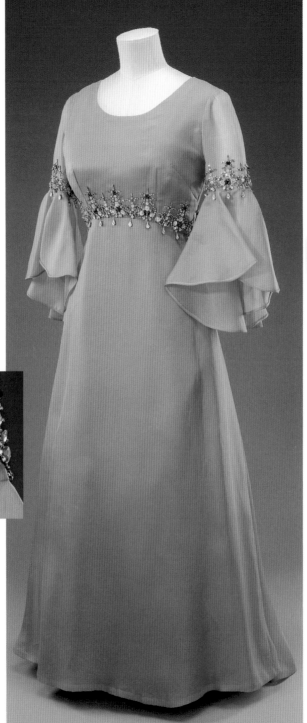

The Queen wore this unusual evening dress of sea-green silk organza with pagoda-shaped sleeves for a farewell banquet at the end of their visit. A band of emerald-coloured diamanté embroidery in a floral design with diamanté drops runs around the waist and the elbows. The full skirt has a layer of organza falling into a soft train. The dress was designed by Ian Thomas.

In 1975 Her Majesty instituted The Queen's Service Order of New Zealand to recognise valuable voluntary service to the community and meritorious and faithful public services. The Queen received the Sovereign's Badge of the Order at Government House, Wellington, on 27 February 1977.

73

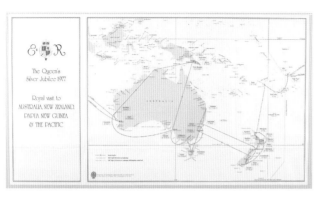

As part of the Silver Jubilee tour, The Queen and The Duke of Edinburgh spent two weeks in New Zealand, during which time The Queen wore her Maori feather cloak for a national welcome by the Maori people at Gisborne.

On several occasions throughout the tour, The Queen wore this green and white floral silk day dress, designed by Norman Hartnell, with a hat of fine green straw by Simone Mirman, trimmed with fabric to match the dress.

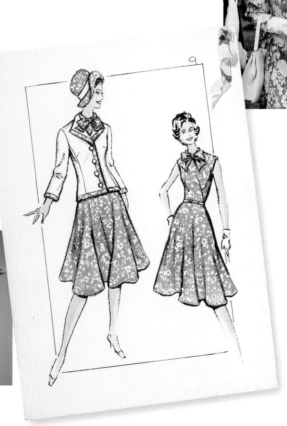

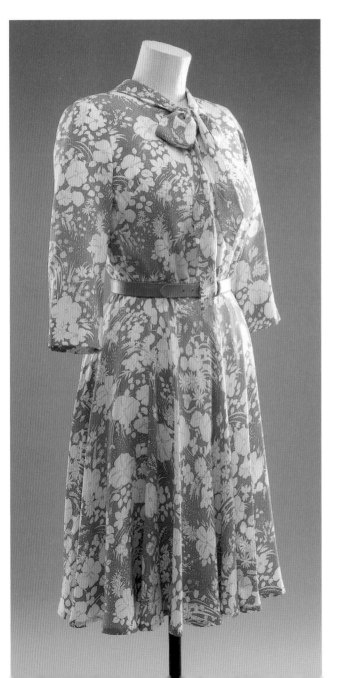

In 1990 The Queen attended the XIV Commonwealth Games in Auckland, which she officially closed. The Queen's most recent visit to New Zealand was in 2002 during her Golden Jubilee tour. In a speech in Wellington on 25 February she spoke of arriving in Auckland Harbour on a misty morning in December 1953 for her first visit.

On 24 February 2002 The Queen unveiled the consecration stone of the Cathedral of St Paul, Wellington, having laid the foundation stone for the cathedral 48 years earlier, on 13 January 1954.

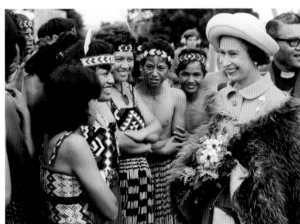

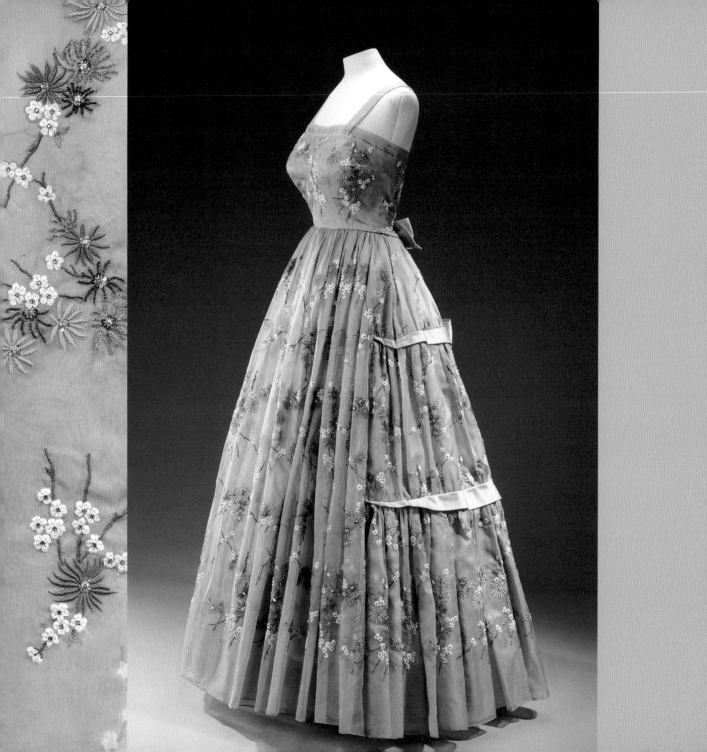

CANADA

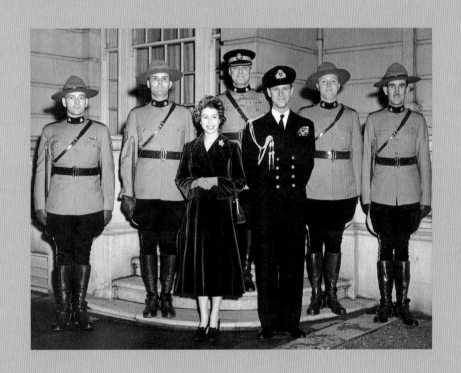

The Queen has an important ceremonial and symbolic role as Queen of Canada, where she is represented by the Governor-General. The Queen has visited Canada, the largest country in the Commonwealth, on 23 occasions over the last 58 years, from her earliest visit in 1951 to her most recent in 2005. Having travelled thousands of miles around the country, she has seen all the provinces, including remote areas never previously visited by a reigning monarch. Some of her most historic journeys have included opening the St Lawrence Seaway in 1959, the celebrations for the centennial anniversary of Confederation in 1967, and the 125th anniversary of Confederation in 1992. She has attended many important Commonwealth events in Canada, including the Commonwealth Conference in Ottawa in 1973, the Commonwealth Heads of Government Meeting in British Columbia in

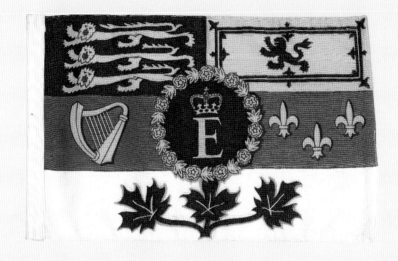

1987 and the Commonwealth Games in Edmonton and Victoria in 1978 and 1994 respectively. The Queen also visited Canada during her Silver Jubilee tour of 1977 and Golden Jubilee tour of 2002, when she visited British Columbia, Manitoba, Ontario, New Brunswick, the National Capital Region. She also made her first visit to the new territory of Nunavut, which was formally established in 1999.

The Queen first visited Canada as Princess Elizabeth in October 1951, when she and The Duke of Edinburgh undertook a tour of the country, covering over 10,000 miles.

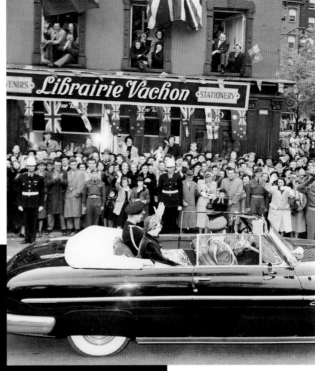

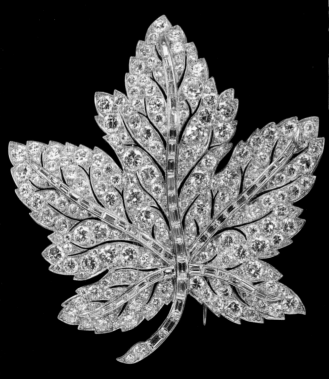

During her tour The Queen wore a brooch of diamonds and platinum in the form of a maple leaf, the national symbol of Canada.

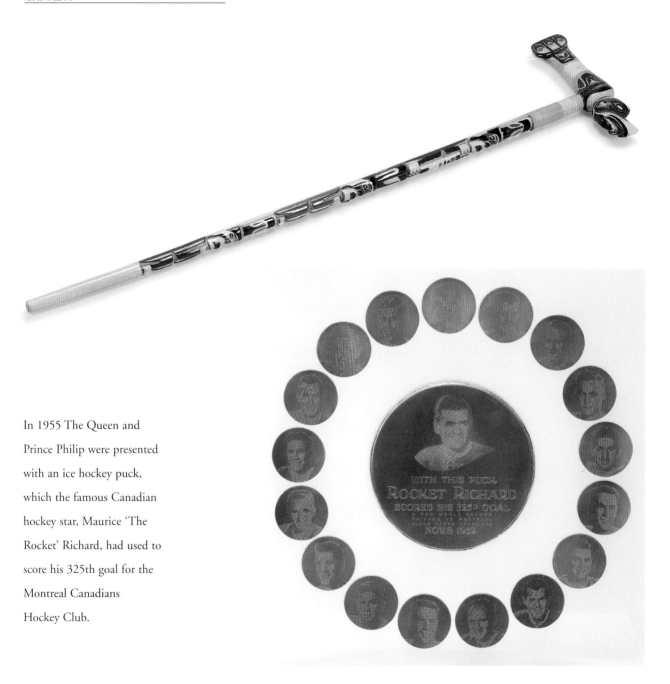

In 1955 The Queen and Prince Philip were presented with an ice hockey puck, which the famous Canadian hockey star, Maurice 'The Rocket' Richard, had used to score his 325th goal for the Montreal Canadians Hockey Club.

In 1957 The Queen returned to Canada, where she opened the new session of the twenty-third Canadian Parliament in Ottawa on 14 October. For the occasion she wore her Coronation Dress for the fourth time on a Commonwealth tour. This was an historic moment, which The Queen recalled in her speech on that occasion:

For the first time the representatives of the people of Canada and their Sovereign are here assembled on the occasion of the opening of Parliament. This is for all of us a moment to remember.

During her visit she also made a television broadcast, in both English and French, from Government House, Ottawa, in which she recalled her tour of the country in 1951 and spoke of the developments in travel, which she said was becoming so quick and easy that she hoped to pay more visits in the future. The Queen also paid a State Visit to Washington DC, as Queen of Canada.

Following her visit in 1957, she was presented with a bronze by Chief Mungo Martin of the Kwakiutl Tribe, British Columbia.

The Queen and The Duke of Edinburgh paid a further visit to Canada in the summer of 1959 to open the St Lawrence Seaway and tour all Canada. In the words of the Prime Minister of Canada, John Diefenbaker, this visit would write 'a new chapter in Canadian and Commonwealth history'.

On 26 June The Queen and Prince Philip were joined by President and Mrs Eisenhower at the opening ceremony. In her speech, The Queen underlined the enormous significance of the project, which had been undertaken by more than 20,000 labourers, engineers and designers from both Canada and the United States:

This distinguished company has come together from two great countries that border this waterway to mark the completion of a combined operation that ranks as one of the outstanding engineering accomplishments of modern times. We can say in truth that this occasion deserves a place in history.

For this tour, as for many others, there was great interest in The Queen's wardrobe. Again there was a very large variety of clothes for the six-week tour, with many different combinations of dresses designed by both Hartnell and Hardy Amies.

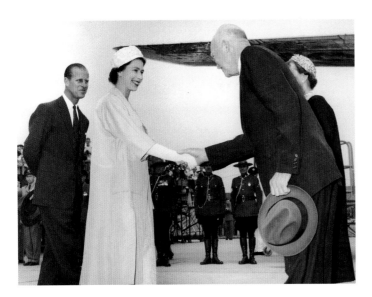

14.

Friday, 31st July, cont'd.

6.00 p.m. A.D.T. Private Dinner, Government House, Halifax

Hartnell No. 11. White satin short evening dress with large silk embroidered roses on the bodice. White satin stole lined with pink. Pink satin shoes and short white mink evening wrap.

Two rows of large pearls and diamond clasp, large pearl and diamond earrings and diamond bracelet.

Saturday, 1st August

10.00 a.m. A.D.T. Visit to Camp Hill Hospital

Hartnell No. 55. Pale beige tussore coat, beige tussore dress with flat back and front and pleated side panels. Tan buttons and belt, pale beige shoes and bag.

Hat: Small hat of burnt apricot organza, swathed and gathered. Gloves to match.

8.15 p.m. Dinner at Government House, Halifax

Hardy Amies No. 17. A summer evening dress in palest grey silk organza entirely embroidered in an apple blossom design. This design is embroidered in silk with highlights of coloured stones. The full, wide crinoline skirt has a ruched bustle back caught down with bands of apple blossom pink satin ribbon.

Diamond tiara, necklace of three rows of diamonds, a diamond bracelet and diamond cluster earrings. Garter Ribbon and Star and Family Orders.

10.30 p.m. Departure from Halifax

Hartnell No. 44. A vivid peacock blue silk tussore dress and full length coat.

Hat: Small toque of patent turquoise petals with two turquoise bows.

Sunday, 2nd August

9.45 a.m. Arrival in London

Hartnell No. 55. Pale beige tussore coat, beige tussore dress with flat back

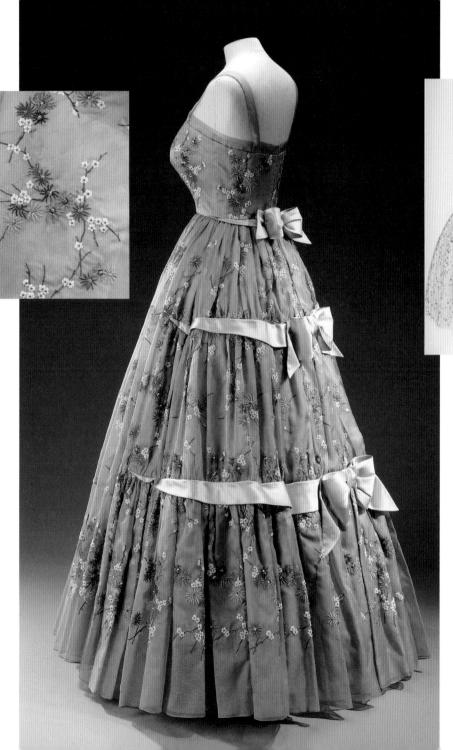

One of Amies's dresses, which
The Queen wore for a dinner at
Government House, Halifax on
1 August, was this elegant pale
grey silk organza evening gown
and matching stole, embroidered
all over with mayflowers (the
emblem of Nova Scotia) and
apple blossom, highlighted with
sequins, beads and diamanté.
At the back of the full crinoline
skirt are three bands of pink
duchesse satin, each caught at the
centre in a bow.

In July 1967 The Queen and The Duke of Edinburgh attended the centennial celebrations of the Confederation of Canada. On Confederation Day, 1 July, the crowd along the route to Parliament in Ottawa, where The Queen addressed representatives of the Senate and the House of Commons, was estimated to total 150,000.

During the afternoon, The Queen was presented with a giant celebratory cake (made of wood but with an edible inner section) weighing one ton, which she cut with a knife which King George VI had used to cut his own birthday cake during his visit to Canada in 1939. Following the celebrations, The Queen and The Duke departed on *Britannia* for Montreal, where they visited the International Expo 67.

For the occasion of the centennial celebrations, Norman Hartnell designed a striking evening gown of white and blue silk crêpe. The bodice terminated in an inverted V-shaped band of embroidery in a design of maple leaves and berries, composed of crystal beads, silver bugle beads, sequins and diamanté.

The embroidery design was a fitting compliment to the Canadian people on this historic occasion, but it was not the first time that Hartnell had created a dress with a maple-leaf motif for The Queen to wear in Canada. In 1957 he had designed a magnificent crinoline gown decorated with maple-leaf embroidery, which The Queen later gave to the Royal Ontario Museum, Toronto.

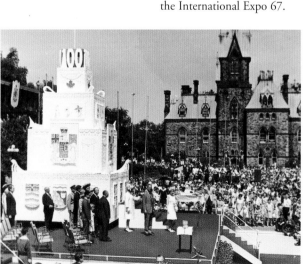

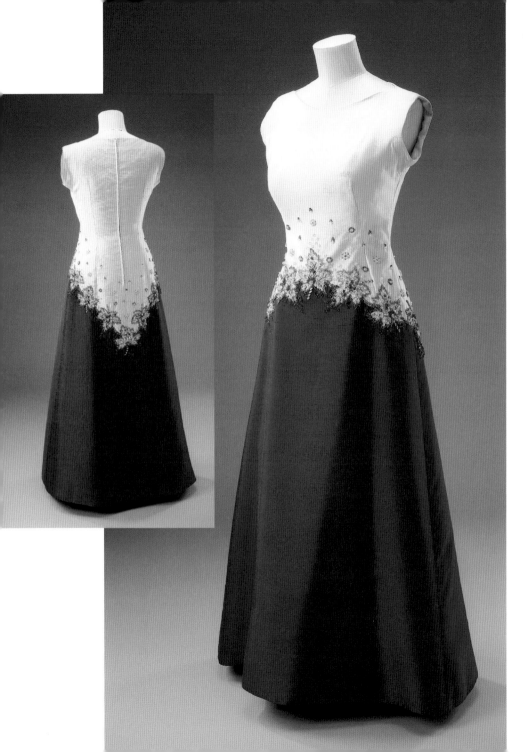

On Canada Day 1967, The Queen, on the advice of her Canadian ministers, instituted the Order of Canada, which allowed her to honour her Canadian subjects with a Canadian order rather than a British one. The badge consists of a six-pointed white design modelled on a snowflake. In the centre is a maple leaf.

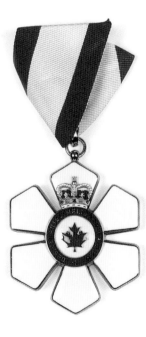

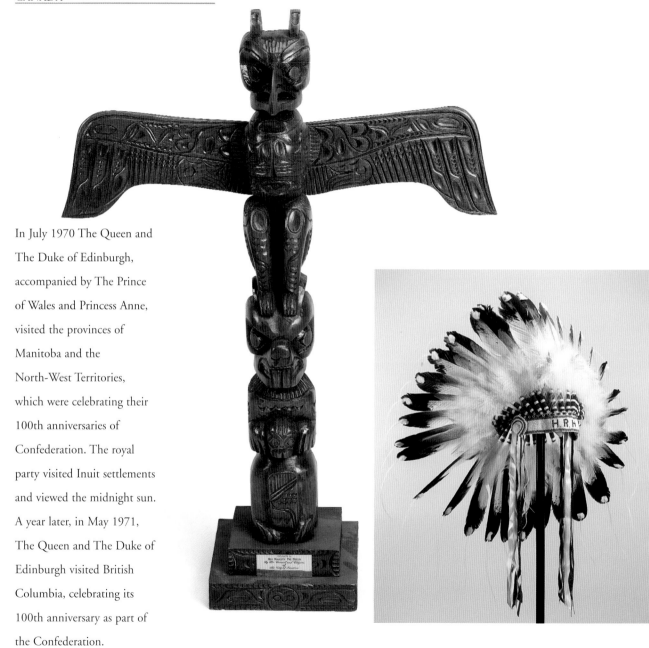

In July 1970 The Queen and The Duke of Edinburgh, accompanied by The Prince of Wales and Princess Anne, visited the provinces of Manitoba and the North-West Territories, which were celebrating their 100th anniversaries of Confederation. The royal party visited Inuit settlements and viewed the midnight sun. A year later, in May 1971, The Queen and The Duke of Edinburgh visited British Columbia, celebrating its 100th anniversary as part of the Confederation.

In 1973 The Queen and The Duke of Edinburgh undertook a tour of Prince Edward Island, Saskatchewan and Alberta, as well as Ottawa, where they were present for the Commonwealth Heads of Government Meeting. During this visit, The Queen was presented with this peace pipe by Chief John Samson.

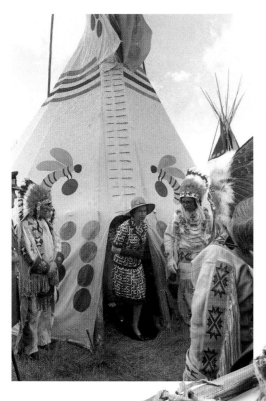

In the city of Regina, Saskatchewan, The Queen received a tapestry of the badge of the Royal Canadian Mounted Police. It was on this occasion that she was also presented with her horse *Burmese*.

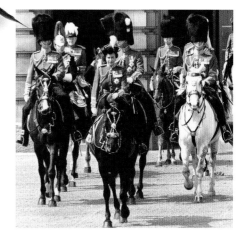

The 1976 Montreal Olympics were opened and attended by The Queen and The Duke of Edinburgh, accompanied by The Prince of Wales, Prince Andrew and Prince Edward. Princess Anne competed in the Games as a member of the British Equestrian Team.

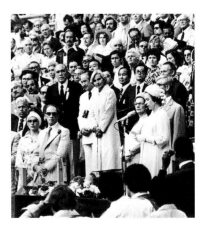

On the occasion of the opening ceremony, the Mayor of Montreal presented The Queen with a silver model of the Olympic Stadium, which had been designed by the French architect Roger Taillibert.

Norman Hartnell designed this dress for The Queen's visit in turquoise silk crêpe. It is embroidered with stylised rings, inspired by the official Olympic symbol, of silver and iridescent sequins, silver beads and turquoise-coloured pearls.

In August 1978 The Queen attended the Commonwealth Games in Edmonton, Alberta, and in 1994 The Queen and Prince Philip again attended the Commonwealth Games, this time in Victoria, British Columbia.

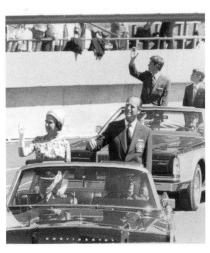

The Queen also visited Canada during her Silver Jubilee year, touring the Ottawa area. On this occasion she received a bronze maple leaf mounted on a block of bird's-eye maple, presented by the Royal Canadian Legion.

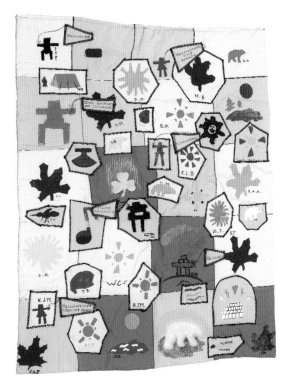

They also returned to the North-West Territories, where they were presented with a quilt made by the Girl Guides of Yellowknife District.

In 1987 The Queen attended the Commonwealth Heads of Government Meeting in Saskatchewan. Among the gifts she received was this model oil rig.

In 1994 The Queen was presented with an Inuit wall hanging by the Department of Northern Affairs and National Resources, Ottawa.

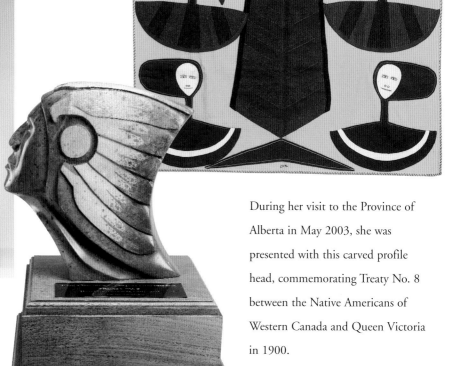

During her visit to the Province of Alberta in May 2003, she was presented with this carved profile head, commemorating Treaty No. 8 between the Native Americans of Western Canada and Queen Victoria in 1900.

As part of the Golden Jubilee celebrations, The Queen visited several provinces of Canada, including British Columbia. She attended a pre-season ice hockey game in Vancouver, where she 'dropped the puck' to the team captains of the Vancouver Canucks and the San Jose Sharks.

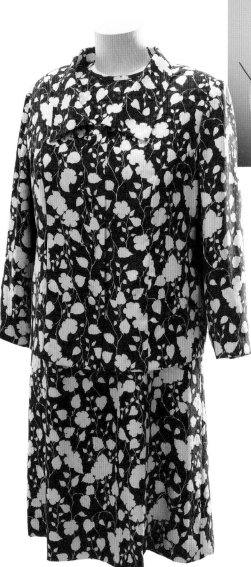

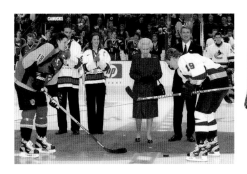

During The Queen's visit to Saskatchewan and Alberta in 2005, she wore this red and white silk dress and jacket, designed by John Anderson. The co-ordinating hat, by Philip Somerville, is of fine straw, trimmed with silk to match the dress and a single feather quill.

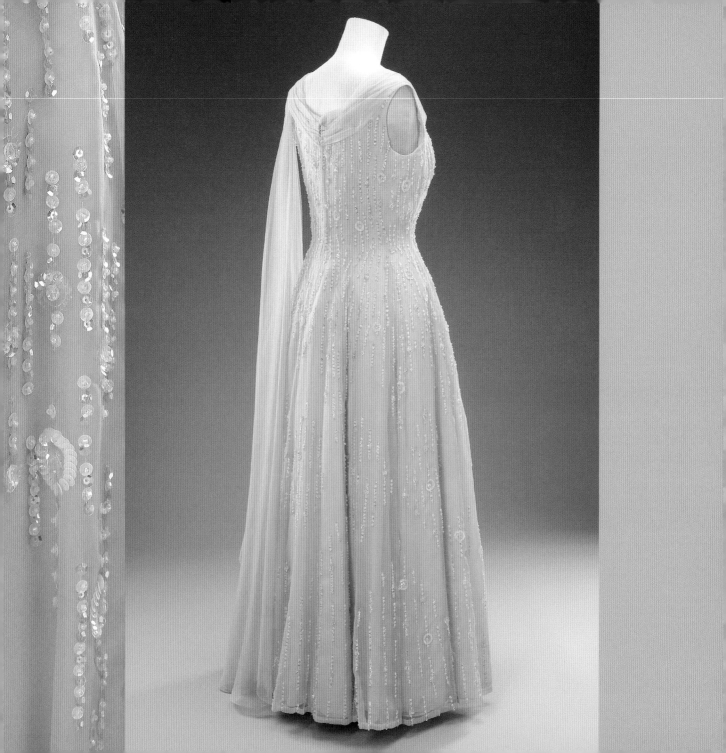

CARIBBEAN
AND
CENTRAL AMERICA

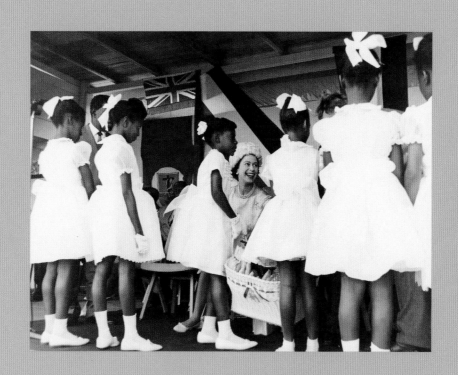

Within the Caribbean and Central America, The Queen is Sovereign in eight realms: Antigua and Barbuda, the Bahamas, Belize, Grenada, Jamaica, St Kitts and Nevis, St Lucia, and St Vincent and the Grenadines. Her first visit to the region was in 1953, when she made her first official stop on the Commonwealth tour, arriving in Bermuda on 24 November and then travelling to Jamaica, where she stayed for three days. In February and March 1966 The Queen and The Duke of Edinburgh undertook a five-week tour of

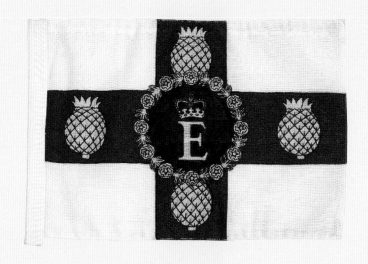

the Caribbean region encompassing Guyana, Trinidad and Tobago, Grenada, St Vincent, Barbados, St Lucia, Dominica, Antigua and Barbuda, St Kitts and Nevis, the Bahamas and Jamaica. The Queen attended the Commonwealth Conference in Jamaica in 1975 and the Commonwealth Heads of Government Meeting in the Bahamas in 1985. Her most recent visit to the region was during her Golden Jubilee year in 2002.

During the first Commonwealth tour, The Queen and The Duke of Edinburgh spent three days in Jamaica. Arriving in Montego Bay, their drive through the heart of the island to the capital, Kingston, was lined with triumphal arches, and cheering crowds gathered in every town and village *en route*. After inspecting military and naval units stationed on the island, The Queen and Prince Philip were welcomed by 20,000 schoolchildren at Sabina Park, home of the Jamaican cricket team.

One of the most charming gifts received during this first visit to the region was a tablecloth and napkins embroidered with Jamaican

plants and birds by the Jamaica Social Service Embroidery Depot and the Jamaica Women's Allsides Workrooms and given by Mrs Michael de Cordova. On a subsequent visit to Jamaica in 1975, The Queen was presented with a similar tablecloth and napkins, the embroidery incorporating the new Jamaican flag.

In February and March 1966, The Queen and The Duke of Edinburgh undertook a five-week tour of the Caribbean which encompassed all The Queen's Caribbean realms as well as British Guiana.

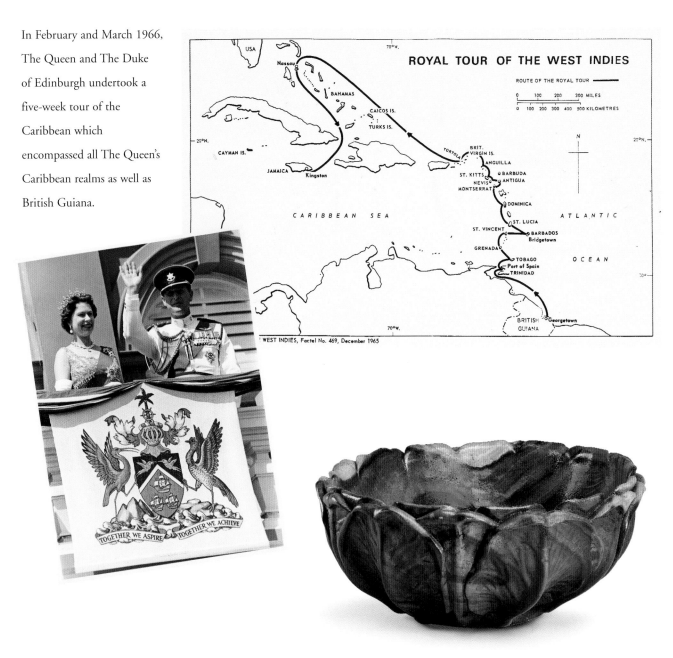

ROYAL TOUR OF THE WEST INDIES

ROUTE OF THE ROYAL TOUR

WEST INDIES, Factel No. 469, December 1965

TOGETHER WE ASPIRE · TOGETHER WE ACHIEVE

On this same visit, The Queen and Prince Philip received a marquetry panel depicting the Arms of Trinidad and Tobago, given by the Allied Builders and Craftsmen's Association, and a circular wooden bowl, carved with cabbage leaves by Theophilus Davis. This was a gift from the Government of Jamaica.

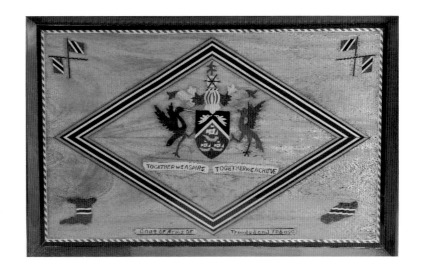

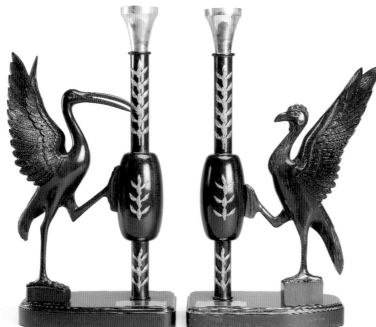

The Queen also addressed Parliament in Port of Spain, Trinidad, and was presented by the Governor of Trinidad and Tobago with a pair of carved wooden candlesticks. These are in the form of the supporters of the Arms of the country, which had been granted by Royal Warrant in 1962.

In 1975 The Queen and The Duke of Edinburgh returned to the Caribbean, visiting Barbados, the Bahamas and Jamaica, for the Commonwealth Heads of Government Meeting in April.

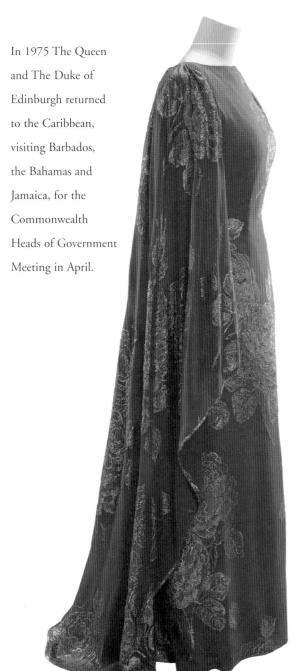

Britannia was used by The Queen and The Duke of Edinburgh as their base. They gave a reception on board for the Heads of Government, for which The Queen wore this silk chiffon evening shift of fuschia pink, embroidered with floral sprays in gold thread. A train in the same fabric falls from the shoulders. The vivid colour and light fabric were ideal for the Caribbean.

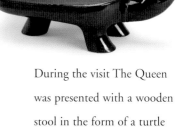

During the visit The Queen was presented with a wooden stool in the form of a turtle by the Government and People of the Commonwealth of Bahamas. The stool is a replica of an 'Arawak Duho' (ceremonial stool) and is made of a local hardwood called madeira.

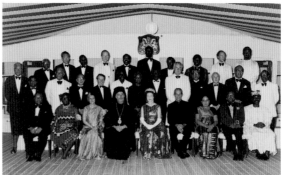

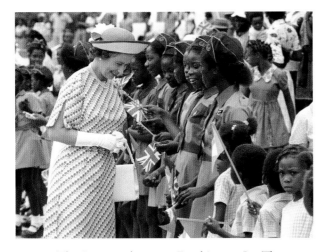

In 1985 The Queen and The Duke of Edinburgh undertook a further tour of the Caribbean and Central America. Between October and early November they visited Belize, the Bahamas (where they attended the Commonwealth Heads of Government Meeting), St Kitts and Nevis, Antigua and Barbuda, Dominica, St Lucia, St Vincent and the Grenadines, Barbados, Grenada, and Trinidad and Tobago.

For this tour, Ian Thomas supplied a number of day and evening dresses, including one of bright yellow organza, the sleeveless bodice edged in gathered organza around the neck, falling into a long scarf over one shoulder, and with a full panelled skirt.

The whole dress is embroidered with iridescent white and yellow sequins in lines and circles in imitation of raindrops.

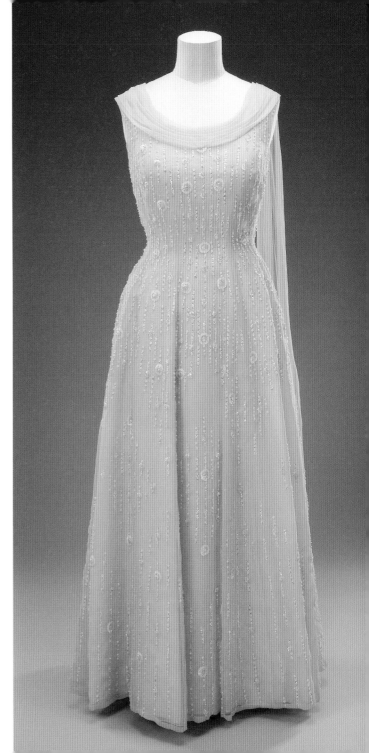

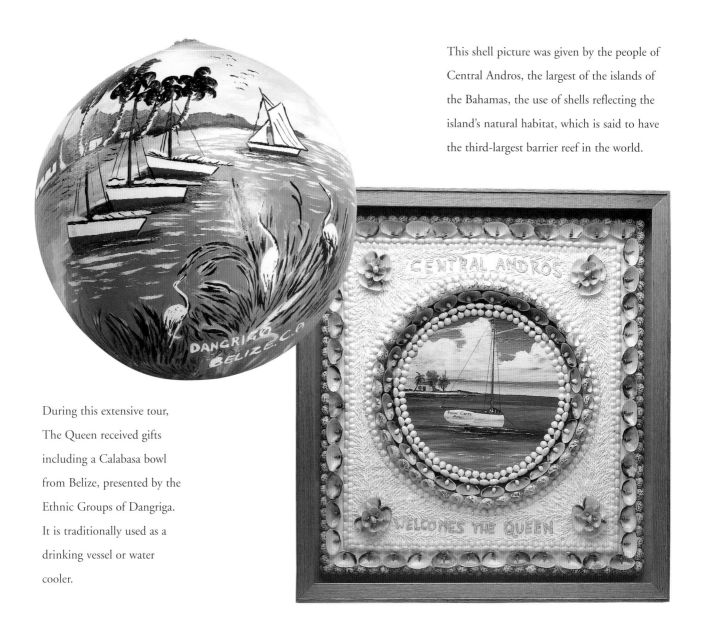

This shell picture was given by the people of Central Andros, the largest of the islands of the Bahamas, the use of shells reflecting the island's natural habitat, which is said to have the third-largest barrier reef in the world.

During this extensive tour, The Queen received gifts including a Calabasa bowl from Belize, presented by the Ethnic Groups of Dangriga. It is traditionally used as a drinking vessel or water cooler.

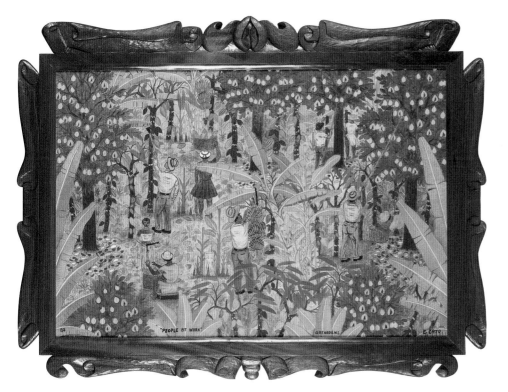

More recently The Queen and The Duke of Edinburgh visited Guyana and Belize in 1994, and Jamaica in February 2002, at the start of the Golden Jubilee tour. During this visit The Queen attended a special session of Parliament at Gordon House, Kingston, and returned to Montego Bay, which she had first visited almost fifty years earlier.

This painting, entitled *A Tropical Harvest*, is by the artist E. Cato. It depicts people at work and the daily life of the island.

This batik of humming birds was given by the Government and People of St Kitts and Nevis.

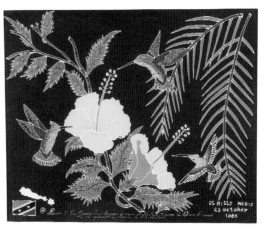

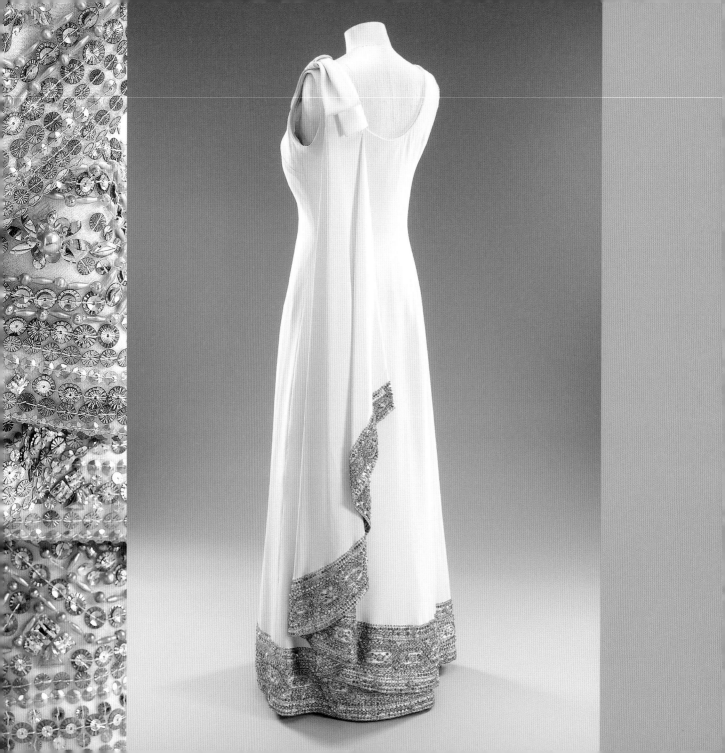

ISLAND PEOPLES
AND
PACIFIC REALMS

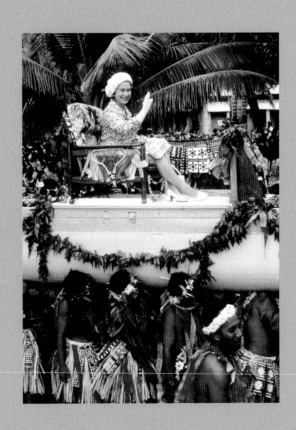

The Queen and The Duke of Edinburgh's most distant travels to Commonwealth countries have included visits to the Pacific Islands of Fiji, Kiribati, Nauru, Papua New Guinea, Samoa, the Solomon Islands, Tonga and Tuvalu. The Queen is Sovereign in three of these island nations – Papua New Guinea, the Solomon Islands and Tuvalu. At the beginning of The Queen's reign these regions were remote and difficult to visit, and for the most part could only be reached by journeys involving days or sometimes weeks at sea.

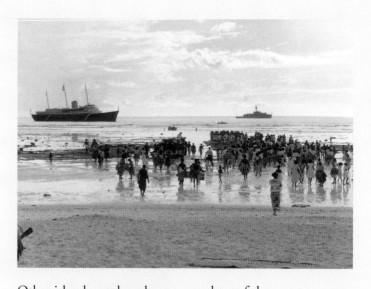

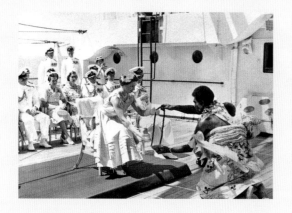

Other island peoples who are members of the Commonwealth include Cyprus, Malta, Mauritius, the Maldives and the Seychelles. The Queen has undertaken a number of tours encompassing all of these countries, from her first Commonwealth tour of 1953, when she spent time in Fiji, Tonga and Malta, to her most recent visit to Malta in 2007.

On 17 December 1953 the SS *Gothic* sailed into the harbour at Suva, the capital of Fiji, bringing The Queen and The Duke of Edinburgh to this region for the very first time. In accordance with the traditional Fijian welcome, outrigger canoes, which had sailed from the surrounding islands, escorted the liner to its anchorage and the Governor-General, Sir Ronald Garvey, came on board to greet Her Majesty. Before The Queen could go ashore, the leading Fijian chiefs were invited on board to perform the ceremony of 'Cavuikelekele', or formal invitation to land, during which the paramount chief offers a Tabua (whale's tooth), the most prized possession of any Fijian ruler.

Once on land, The Queen visited Albert Park to witness Fijian dancing. There she drank a ceremonial cup of 'Yangona', prepared from pounded roots of the kava plant. The Queen has taken part in this traditional welcome ceremony on her subsequent visits to the region. In 1982 she was presented with this traditional carved wooden kava bowl.

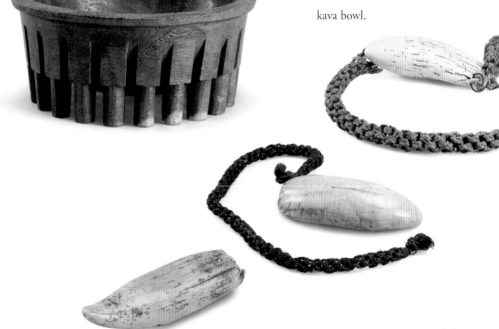

After her visit to Fiji, The Queen and Prince Philip continued to Tonga, where they were received by Queen Salote and the Crown Prince Tungi in the capital, Nukualofa. The arrival route was lined over its entire length with a carpet of tapa cloth, the fabric of the islands, and decorated with triumphal arches.

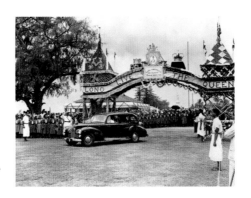

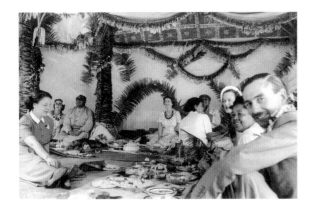

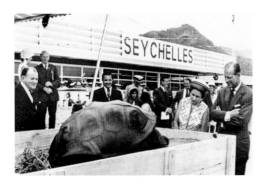

The climax of the first day of the visit to Tonga was the traditional welcome feast, where pyramids of roast suckling pigs, yams, coconuts and fruits were laid out in enormous quantities. During her visit The Queen was introduced to the oldest inhabitant of Tonga, the famous tortoise Tui Malila, reputed to have been brought to the island by Captain Cook.

The Queen and The Duke of Edinburgh have often combined visits to Fiji, Tonga and other Pacific Islands with their visits to Australia and New Zealand, particularly when *Britannia* was used to undertake the journey. The Queen visited Fiji in 1963 and again in 1970, when she also visited Tonga for the second time. In the same year the Premier of the Cook Islands, Albert R. Henry, presented The Queen with this traditional carving, decorated with shell.

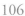

In 1972 The Queen paid her first visit to the Seychelles, the Maldives and Mauritius, as part of an extended tour of the Commonwealth. While in the Maldives she received the Order of Ghaazi. In 1974 The Queen visited Papua New Guinea for the first time, The Duke of Edinburgh having visited independently during his tour of 1956–7. The gifts received during this visit to the Pacific Islands are richly diverse and closely representative of the native materials of the sparsely populated regions and islands.

One of the most unusual gifts was a Slit Gong made on Ambrym Island and presented in Vila in the New Hebrides. It is carved in human form from a hollowed-out tree trunk, and is traditionally used as a means of summoning villagers to a town meeting. The Slit Gong was carried back to England on *Britannia*, where it was placed in the Savill Gardens at Windsor.

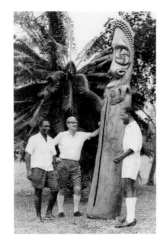

In Papua New Guinea The Queen was presented with a carved crocodile, made by the donor, Mr Peter Pomat of Rossun Village, Manus Island. The carved crocodile is the traditional symbol of the village chiefs or herdsmen on Manus Island.

She also received a carved wooden figure of a traditional warrior, presented by Sir Michael Thomas Somare, the Prime Minister.

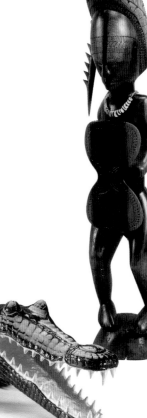

107

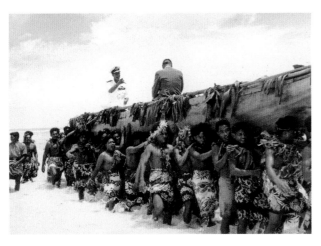

In February and March 1977 The Queen visited Tonga, Fiji and Papua New Guinea as part of her Silver Jubilee tour.

In October and November 1982 The Queen and The Duke of Edinburgh made an extensive tour of the Pacific Islands, including Papua New Guinea, the Solomon Islands, Naura, Kiribati and Tuvalu. On arrival in Tuvalu, The Queen and The Duke of Edinburgh were carried ashore from *Britannia*, held aloft in canoes.

The Queen received a traditional Dala head ornament of clamshell and turtleshell from the Solomon Islands. She was also presented with a ceremonial sword of shark's teeth from Kiribati.

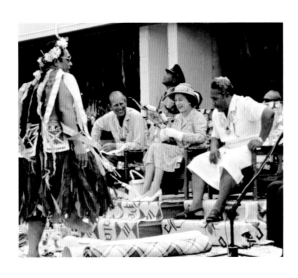

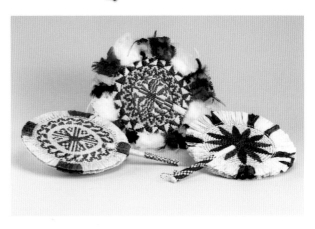

In 1996 the people of Papua New Guinea presented The Queen with a painting by Mathias Kauage. According to the artist, this represents The Queen as Head of the Commonwealth.

At the most recent Commonwealth Heads of Government Meeting, held in Uganda in 2007, the Prime Minister of Papua New Guinea presented The Queen with a black-glazed pottery vase decorated with lizards.

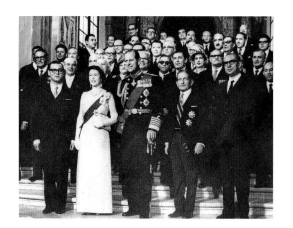

On this occasion The Queen opened the Maltese Parliament. She wore a dress designed by Hardy Amies of ivory duchesse satin with lace in gold and silver thread. The straps and neckline are embroidered with diamanté.

In 1949–51 The Queen (when Princess Elizabeth) joined The Duke of Edinburgh in Malta, where he was stationed as a serving Royal Navy officer. They revisited in May 1954, on the return leg of their first Commonwealth tour, but it was not until November 1967 that The Queen made her first visit as Sovereign to an independent Malta.

For another evening engagement during the four-day visit, The Queen wore an elegant evening dress of plain ivory silk crêpe. A bow on the left shoulder falls into a draped panel of fabric. The hem of the skirt is embroidered with a band of rich gold and silver sequin and bead embroidery.

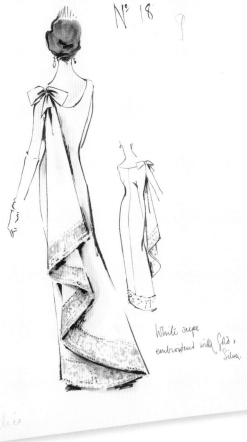

CHOGM = Commonwealth Heads of Government Meeting

AFRICA

1954 28 - 30 April
Uganda

1956 28 January
- 16 February
Nigeria

1961 9 - 20 November
Ghana

25 November
- 1 December
Sierra Leone

3 - 5 December
The Gambia

1972 26 March
Kenya

1979 22 - 25 July
State Visit Malawi

25 - 27 July
State Visit Botswana

27 July - 4 August
State Visit Zambia

1 - 4 August
CHOGM Lusaka,
Zambia

1983 10 - 14 November
State Visit Kenya

1991 7 - 8 October
Overnight stop Kenya,
Nairobi

8 - 10 October
Namibia

15 - 19 October
CHOGM Harare,
Zimbabwe

1995 19 - 25 March
South Africa

1999 7 - 15 November
Ghana, CHOGM
Durban, South Africa,
Mozambique

2003 3 - 6 December
CHOGM Abuja, Nigeria

2007 21 - 24 November
CHOGM Kampala,
Uganda

ASIA

1954 10 - 21 April
Ceylon

1961 21 January - 1 February
India

1 - 16 February
Pakistan

16 - 26 February
India

1 - 2 March
India

1972 18 - 20 February
Singapore

22 - 28 February
Malaysia

29 February
Brunei

2 March
Malaysia

5 March
Singapore

6, 8 March
Malaysia

1974 22 March
Singapore

1981 21 - 25 October
State Visit Sri Lanka

1983 14 - 17 November
Bangladesh

17 - 26 November
India
CHOGM New Delhi
(23 - 26 November)

1989 9 - 11 October
State Visit Singapore

14 - 21 October
Malaysia
CHOGM
Kuala Lumpur
(17 - 21 October)

1997 6 - 18 October
Pakistan and India

1998 17 - 20 September
Brunei

20 - 23 September
Commonwealth Games,
Malaysia

2006 16 - 18 March
Singapore

AUSTRALIA

1954 3 February - 1 April

1963 18 February - 21 March

1970 30 March - 3 May

1973 17 - 22 October

1974 27 - 28 February

1977 Silver Jubilee
7 - 23 March
26 - 30 March

1980 24 - 28 May

1981 26 September
- 12 October,
CHOGM Melbourne

20 - 21 October
Perth overnight stop

1982 5 - 13 October
Commonwealth
Games, Brisbane

1986 2 - 13 March

1988 19 April - 10 May

1992 18 - 25 February

2000 17 March - 1 April

2002 Golden Jubilee
27 February - 3 March

2006 11 - 16 March

NEW ZEALAND

1953-4 23 December
- 30 January

1963 6 - 18 February

1970 12 - 30 March

1974 30 January
- 8 February
Commonwealth
Games, Christchurch

11 February
Norfolk Island

15 - 16 February
New Hebrides

1977 Silver Jubilee
22 February
- 7 March

1981 12 - 20 October

1986 22 February
- 2 March

1990 1 - 16 February
Commonwealth
Games, Auckland

1995 30 October
- 11 November
CHOGM Auckland

2002 Golden Jubilee
22 - 27 February

CANADA

1957 12 - 16 October
Ontario

1959 18 June - 1 August

1963 31 January - 1 February
Vancouver

1964 5 - 13 October

1967 29 June - 5 July

1970 2 - 3 March
Vancouver

5 - 15 July
Northwest Territories
and Manitoba

1971 3 - 12 May
British Columbia

1973 25 June - 6 July

31 July - 4 August
inc. CHOGM Ottawa

1976 13 - 26 July
Nova Scotia, New
Brunswick and
Olympic Games,
Montreal

1977 Silver Jubilee
14 - 19 October
Ottawa area

1978 26 July - 6 August
Touring and
Commonwealth
Games, Edmonton

1982 15 - 18 April
Ottawa

1983 8 - 11 March
British Columbia

1984 24 September - 7 October

1987 9 - 24 October
CHOGM Vancouver

13 - 17 October
Saskatchewan
and Quebec

1990 25 June - 1 July

1992 30 June - 2 July

1994 13 - 22 August
Commonwealth
Games, Victoria

1997 23 June - 2 July

2002 Golden Jubilee
4 - 15 October

2005 7 - 25 May

CARIBBEAN & CENTRAL AMERICA

1953 25 - 27 November
Jamaica

1966 1 February
Barbados

4 - 5 February
British Guiana

7 - 9 February
Trinidad

10 February
Tobago

11 February
Grenada

13 February
St Vincent

14 - 15 February
Barbados

16 February
St Lucia

18 February
Dominica

20 February
Antigua

22 February
St Kitts-Nevis

27 - 28 February
The Bahamas

3 - 6 March
Jamaica

1975 18 - 20 February
Barbados

20 - 21 February
The Bahamas

26 - 30 April
CHOGM Kingston, Jamaica

1977 Silver Jubilee
19 - 20 October
The Bahamas

28 October
Antigua

31 October - 2 November
Barbados

113

1983 13 - 16 February
Jamaica

1985 9 - 11 October
Belize

11 - 18 October
The Bahamas inc.
CHOGM Nassau

23 October
St Kitts-Nevis

24 October
Antigua and Barbuda

25 October
Dominica

26 October
St Lucia

27 October
St Vincent and
the Grenadines

28 - 29 October
Barbados

31 October
Grenada

1 - 3 November
Trinidad and Tobago

1989 8 - 11 March
Barbados

1994 19 - 24 February
Guyana and Belize

1 - 10 March
Jamaica

2002 **Golden Jubilee**
18 - 20 February
Jamaica

ISLAND PEOPLES
& PACIFIC REALMS

1953 17 - 18 December
-54 Fiji

19 - 20 December
Tonga

5 April
Cocos Islands

3 - 7 May
Malta

1961 20 January
Cyprus

1963 1 - 2 February
Fiji

1967 14 - 17 November
Malta

1970 4 - 5 March
Fiji

7 March
Tonga

1972 13 - 14 March
State Visit Maldives

19 - 20 March
Seychelles

24 - 26 March
Mauritius

1973 16 - 17 October
Overnight stop Fiji

1974 28 - 29 January
Cook Islands

18 - 21 February
Solomon Islands

22 - 27 February
Papua New Guinea

1977 **Silver Jubilee**
10 - 11 February
Western Samoa

14 February
Tonga

16 - 17 February
Fiji

23 - 26 March
Papua New Guinea

1982 13 - 14 October
Papua New Guinea

18 October
Solomon Islands

21 October
Nauru

23 October
Kiribati

26 - 27 October
Tuvalu

30 October
- 1 November
Fiji

1983 9 - 10 November
Cyprus

1992 28 - 30 May
State Visit Malta

2007 20 November
Malta

Illustrations

Unless otherwise stated, all illustrations are The Royal Collection © 2009, HM Queen Elizabeth II. Items with RA references are The Royal Archives © 2009, HM Queen Elizabeth II. Royal Collection Enterprises are grateful for permission to reproduce those items listed below for which copyright is not held by the Royal Collection or Royal Archives.

p. 26
• The Queen and The Duke of Edinburgh receiving gifts from an Ashanti Chief, including a model of a Royal Procession (see title page) Ghana, 1961 (RCIN 2003153): Copyright reserved/The Royal Collection
• *Royals on Tour, 1961*: Keystone/Hulton Archive/Getty Images
• Carved ivory lamp, Sierra Leone, 1961 (RCIN 99507)

p. 27
• Carved wooden stool, Ghana, 1972 (RCIN 93042)
• Gold brooch in the form of a porcupine, Ghana, 1972 (RCIN 250036)

p. 28
• *HM The Queen and President Jomo Kenyatta, 1972*: Lichfield/Lichfield Archive/Getty Images
• Breast Star and Collar of the Order of the Golden Heart (RCIN 250042.a-b)
• Marble sculpture of an eagle, Kenya, 1983 (RCIN 2267)

p. 29
• Woollen wall hanging, Botswana, 1979 (RCIN 69532)
• Wooden carving (*Chauta's Family*), Malawi, 1985: Wilson Tibu (RCIN 93048)

p. 30-31
• *The Queen, President and Mrs Kaunda of Zambia, 1983* (RCIN 2004406): Copyright reserved/The Royal Collection
• Silk-velvet evening dress with diamanté, sequin and bugle bead embroidery: Ian Thomas, 1983 (RCIN 250024)

p. 32
• Painted pottery pieces from a chess set, South Africa, 1996 (RCIN 99512)

p. 33
• Grand Cross of the Order of Good Hope (RCIN 250046)
• Silk chiffon dress: Maureen Rose Couture, *c.*1995 (RCIN 250021)
• *The Queen and former South African President Nelson Mandela with Chantel Malambo, Pretoria, 1999*: PA Photos

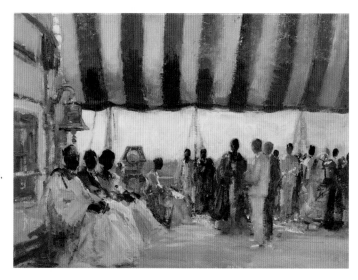

p. 34
• *The Queen meeting Accra Chiefs, 1999*: Tim Graham/Tim Graham Photo Library/Getty Images
• Silk hat: John Anderson, 1999 (RCIN 250029.b)
• Silk day dress: John Anderson, 1999 (RCIN 250029.a)

p. 35
• Robert Aryeetey, *Royal Pageant*, 1998 (oil on canvas; RCIN 407768)
• Woven address of welcome, Ghana, 1998 (RCIN 94582)

p. 36
• Straw and feather hat: Philip Somerville, 2003 (RCIN 250023.c)
• Silk day dress and jacket: Kelly & Pordum, 2003 (RCIN 250023.a-b)

p. 37
• *The Queen in Karu, Nigeria, 2003*: PA Photos
• *The Queen and The Duke of Edinburgh watch children performing a fashion show, Mildmay International Centre, Uganda, 2007*: PA Photos

ASIA

p. 38
• Evening gown of silk faille and china beads: Norman Hartnell, 1961 (RCIN 100096)

p. 39
• *The Queen riding an elephant in India, 1961*: Popperfoto/Popperfoto/Getty Images

p. 40
• Model of the Qutb Minar, 1961 (ebonised wood, ivory, silver; RCIN 69213)

p. 41
• *Map of the Royal Tour, 1961* (RCIN 2002796): Copyright reserved/The Royal Collection
• *The Queen arriving at Delhi airport, 1961*: Popperfoto/Popperfoto/Getty Images

p. 42
• *The Queen and The Duke of Edinburgh with President Prasad at the banquet in the Presidential Palace, New Delhi, 1961* (RCIN 2002800), detail: Copyright reserved/The Royal Collection
• Sketch for a pearl embroidered evening dress: Norman Hartnell, *c.*1960: Private collection
• Lace evening gown and bolero jacket re-embroidered with pearls, sequins and bugle beads: Norman Hartnell, 1961 (RCIN 100097.a-b)

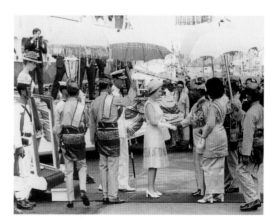

p. 62
• Painted wood boomerang, 1963 (RCIN 92818)
(An identical boomerang was presented to each of
the participating teams at the British Empire and
Commonwealth Games, Perth, November 1962)
• Painted wood boomerang and shield: Billy
Stockman, 1992 (RCIN 93023.a-b)
• Silver boomerang set with an opal: Kenneth
Mansergh, 1992 (RCIN 94135)
• Painted wood carving of a dugong: Stephen
Kawurlkku, 2000 (RCIN 94114)

p. 63
• *The Queen at Sydney Races, 1970*:
Keystone/Hulton Archive/Getty Images
• Mimosa-yellow wool crêpe day dress and coat:
Norman Hartnell, 1970 (RCIN 250017.a-b)
• Straw and silk hat: Simone Mirman, 1970
(RCIN 250017.c)

p. 64
• Evening gown of silk embroidered with beads
and sequins: Norman Hartnell, 1973 (RCIN
100038)

p. 65
• Fred Williams, *Sydney Opera House and Harbour
Bridge*, 1973 (oil on canvas;
RCIN 407428)
• *The Queen at Melbourne Zoo, 1977*:
photograph by Camera Press London
• The Order of Australia: Dame's Badge, 1975
(RCIN 441549.a-d)
• Day dress and jacket in silk and linen: Ian
Thomas, 1977 (RCIN 250015.a-b)

p. 66
• The Queen's personal flag for New Zealand
(RCIN 93462)

p. 67
• *The Queen and The Duke of Edinburgh greeted
by King Koroki, Ngaruawahia, January 1954*
(RCIN 2004028)
• Tapestry depicting Mount Cook, 1953
(RCIN 94822)
• Greenstone mere 'Budding Cloud' (RCIN
37065)

p. 68
• Diamond brooch in the form of a silver fern,
1953 (RCIN 250032)
• Kiwi-feather cloak, 1954 (RCIN 74630)

p. 69
• Carved wooden box containing feathers, 1954
(RCIN 94943)
• Maori bag, 1981 (flax and kiwi feathers;
RCIN 32171)

p. 70
• *The Queen and The Duke of Edinburgh at Waka
Thermal Reserve, 1953-4*: Copyright reserved/
The Royal Collection
• *The Queen and The Duke of Edinburgh,
Wellington, 1954* (RCIN 2823112): Copyright
reserved/The Royal Collection

p. 71
• Evening gown of gold lamé overlaid with lace
re-embroidered in gold: Norman Hartnell, 1954
(RCIN 200112)

p. 72
• *The Queen and The Duke of Edinburgh opening
Parliament in Wellington, 1963*: Hulton Archive/
Hulton Archive/Getty Images
• Evening gown of oyster duchesse satin
embroidered with pearls, beads and sequins:
Norman Hartnell, 1963 (RCIN 100050)

p. 73
• Evening gown of green silk organza with
diamanté embroidery: Ian Thomas, 1974
(RCIN 100082)
• The Queen's Service Order, New Zealand:
Sovereign's Badge, 1975 (RCIN 441553)

p. 74
• Map of the Silver Jubilee tour: Copyright
reserved/The Royal Collection
• *The Queen's Silver Jubilee visit to New Zealand,
1977*: Anwar Hussein/Getty Images
Entertainment/Getty Images
• Sketch for dress, jacket and hat:
Norman Hartnell, *c.*1977: Private collection
• Straw and silk hat: Simone Mirman, 1977
(RCIN 250018.b)

p. 75
• Silk day dress: Norman Hartnell, 1977 (RCIN
250018.a)
• *The Queen meeting Maoris at Gisborne, 1977*:
Anwar Hussein/Getty Images Entertainment/
Getty Images

CANADA

pp. 76 and 83
• Evening gown of grey organza embroidered
with mayflowers and apple blossom in sequins,
beads and diamanté: Hardy Amies, 1959
(RCIN 100071.a)

p. 77
• *Princess Elizabeth with members of the Royal
Canadian Mounted Police, 1951*: Hulton
Archive/Hulton Archive/Getty Images

p. 78
• The Queen's personal flag for Canada
(RCIN 93469)

p. 79
• *The Queen and The Duke of Edinburgh driving
through Québec City, 1951* (RCIN 2706798):
Copyright reserved/The Royal Collection
• Diamond brooch in the form of a maple leaf
(RCIN 250031)

p. 80
• Painted wooden walking stick, 1953
(RCIN 67734)
• Engraved hockey puck, 1955 (RCIN 92546)

p. 81
• Bronze plaque, 1957 (RCIN 69833)

p. 82
• *President Eisenhower greets The Queen, 1959*:
Fox Photos/Hulton Archive/Getty Images
• List of dresses worn by The Queen during
the tour of Canada, 1959: Copyright
reserved/The Royal Collection

p. 83
• Sketch for the mayflower evening gown (pencil,
watercolour): Hardy Amies, *c.*1959: Hardy Amies
London Limited

p. 84
• *The Queen and The Duke of Edinburgh at
Parliament Hill, Ottawa, 1967* (RCIN 2003660):
Copyright reserved/The Royal Collection
• Detail of maple leaf embroidery from an evening
gown of white and blue silk crêpe

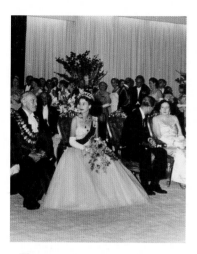

p. 85
• Evening gown of white and blue silk crêpe embroidered with crystal beads, sequins and diamanté in the form of maple leaves: Norman Hartnell, 1967 (RCIN 100049)
• The Order of Canada: Companion's Badge, 1967 (RCIN 441545)

p. 86
• Wooden totem pole, 1971 (RCIN 92098)
• Feather headdress, c.1970 (RCIN 70156)

p. 87
• *The Queen in Alberta, 1973*: Popperfoto/Popperfoto/Getty Images
• Peace pipe, 1973 (RCIN 92649)
• Tapestry of the Badge of the Royal Canadian Mounted Police, 1973 (RCIN 91646)
• *The Queen riding Burmese for the Birthday Parade, June 1978* (RCIN 2007292): Copyright reserved/The Royal Collection

p. 88
• *The Queen opening the Montreal Olympics, 1976*: photograph by Canada Wide, Camera Press London
• Silver model of the Montreal Olympic stadium, 1976 (RCIN 49676.a)
• Evening gown in turquoise silk crêpe embroidered with stylised Olympic rings: Norman Hartnell, 1976 (RCIN 100067)

p. 89
• Bronze maple leaf mounted on a block of maple, 1977 (RCIN 92776)
• Patchwork quilt, 1994 (RCIN 94834)
• *The Queen at the Commonwealth Games, Edmonton, 1978*: PA Photos

p. 90
• Brass model of an oil rig, 1987 (RCIN 94498)
• Hardstone carved profile head on a wooden base, 2003 (RCIN 95886)
• Wool and felt Inuit wall hanging, 1994 (RCIN 94126)

p. 91
• *The Queen at a hockey match, 2002*: PA Photos
• Red and white silk dress and jacket: John Anderson, 2005 (RCIN 250022.a-b)
• Hat of fine straw and silk: Philip Somerville, 2005 (RCIN 250022.c)

CARIBBEAN
AND
CENTRAL AMERICA

p. 92
• Yellow organza evening gown embroidered with sequins and beads: Ian Thomas, 1985 (RCIN 100085)

p. 93
• *The Queen and The Duke of Edinburgh in Montserrat, 1966* (RCIN 2003960): Copyright reserved/The Royal Collection

p. 94
• The Queen's personal flag for Jamaica (RCIN 93468)
• *Walkabout in Nassau, The Bahamas, 1966* (RCIN 2003946): Copyright reserved/The Royal Collection

p. 95
• *The Queen and The Duke of Edinburgh, Sabina Park, Jamaica, 1953*: Popperfoto/Popperfoto/Getty Images
• Embroidered linen tablecloth and napkins, Jamaica, 1975 (RCIN 95502)

p. 96
• *Map of the Royal Tour of the West Indies, 1966* (RCIN 2004006): Copyright reserved/The Royal Collection
• *The Queen and The Duke of Edinburgh at Parliament House, Port of Spain, Trinidad, 1966* (RCIN 2003962): PA Photos
• Carved wooden bowl, Jamaica, 1966 (RCIN 92628)

p. 97
• Marquetry panel, 1966 (RCIN 92744)
• Carved wooden candlesticks, Trinidad and Tobago, 1966 (RCIN 92837.a-b)

p. 98
• Evening gown of fuschia pink chiffon embroidered with floral sprays: Norman Hartnell, 1975 (RCIN 250026)
• Madeira stool in the form of a turtle, 1975 (RCIN 92639)
• *The Queen at the Commonwealth Heads of Government Meeting, Jamaica, 1975* (RCIN 2506544): Copyright reserved/The Royal Collection

p. 99
• *The Queen in Antigua, 1977* (RCIN 2003998): PA Photos
• Yellow organza evening gown embroidered with sequins and beads: Ian Thomas, 1985 (RCIN 100085)

p. 100
• Carved and painted coconut Calabasa bowl, Belize, 1985 (RCIN 92167)
• Shell plaque, Bahamas, 1985 (RCIN 72553)

p. 101
• E. Cato, *A Tropical Harvest*, 1985 (bodycolour on wood; RCIN 407753)
• Batik painting of three humming birds, 1985 (RCIN 94408)

ISLAND PEOPLES
AND
PACIFIC REALMS

p. 102
• Evening gown of silk crêpe with gold and
silver embroidery: Norman Hartnell, 1967
(RCIN 250025)

p. 103
• *The Queen in Tuvalu, 1982*: Anwar Hussein/
Getty Images Entertainment/Getty Images

p. 104
• *The Duke of Edinburgh leaving Vanuatu, 1957*:
Copyright reserved/The Royal Collection
• *The Queen and The Duke of Edinburgh
attending a welcome ceremony aboard SS Gothic,
Suva, Fiji, 1953*: PA Photos

p. 105
• *Ratu G.K. Cakobau, High Chief of Fiji, presents
Tabua to The Queen, 1963* (RCIN 2002783):
Copyright reserved/The Royal Collection
• Wooden kava bowl, 1982 (RCIN 92529)
• Three Tabuas (sperm whale's teeth)
(RCIN 60250, 60118, 94939)

p. 106
• *Triumphal arch, Tonga, 1954*: PA Photos
• *The Queen and Queen Salote of Tonga at a feast,
1954*: Copyright reserved/The Royal Collection
• *The Queen and The Duke of Edinburgh with a
giant tortoise, Seychelles, 1972* (RCIN 2002851):
Copyright reserved/The Royal Collection
• Carved wooden figure with shell decoration,
1970 (RCIN 90758)

p. 107
• *Slit gong presented to The Queen by Chief Tofor,
Ambrym Island, New Hebrides, 1974* (RCIN
2003892): Copyright reserved/The Royal
Collection
• Carved wooden crocodile, 1974 (RCIN 92603)
• Carved wooden figure of a warrior, 1974
(RCIN 94134)

p. 108
• *The Duke of Edinburgh, Vaitupu, Vanuatu,
1956*: Copyright reserved/The Royal Collection
• *The Queen in the South Sea Islands, 1982*:
PA Photos
• Dala head ornament with turtleshell and
clamshell medallion, 1982 (RCIN 92175.a)
• Circular woven raffia fans, 2002 (RCIN
200279, 95897, 200280)

p. 109
• Matthias Kauage, *Queen Elizabeth II in
ceremonial headdress*, 1996 (oil on canvas;
RCIN 407778)
• Black glazed pottery vase, 2007 (RCIN 95991)

p. 110
• *The Queen and The Duke of Edinburgh, Malta,
1967*: Central Press/Hulton Archive/Getty
Images
• Ivory duchesse satin and lace evening gown
re-embroidered with beads and diamanté: Hardy
Amies, 1967 (RCIN 250028)
• Sketch for satin and lace evening gown (pencil
and watercolour): Hardy Amies, 1967: Hardy
Amies London Limited

p. 111
• Evening gown of silk crêpe with gold and silver
embroidery: Norman Hartnell, 1967
(RCIN 250025)
• Sketch for silk crêpe embroidered evening
gown: Norman Hartnell, 1967: Private collection

pp. 114 and 120
• Magazine covers from *The Royal Tour*, 1953
(RA F&V/visov/comm/1953-4/Pitkin Pictorial
Guides of the Royal Commonwealth Tour)

p. 116
• Edward Seago, *The Duke of Edinburgh with
African guests on board HMY Britannia, c.1956-7*
(oil on canvas; RCIN 401306)

p. 117
• *The Queen arriving in Malaysia, 1972* (RCIN
2004082): Copyright reserved/The Royal
Collection

p. 119
• *The Queen at the City of Melbourne Ball, 1954*
(RCIN 2506546): Copyright reserved/The Royal
Collection